How To Photograph

Under~ water

How To Photograph Underwater

Norbert Wu

STACKPOLE
BOOKS

Published by
STACKPOLE BOOKS
5067 Ritter Road
Mechanicsburg, PA 17055

Printed in Hong Kong

10 9 8 7 6 5 4 3 2 1

First edition

Cover design by Tracy Patterson with Kathy Peters

Library of Congress Cataloging-in-Publication Data

Wu, Norbert.
 How to photograph underwater / Norbert Wu. — 1st ed.
 p. cm.
 Includes bibliographical references (p.).
 ISBN 0-8117-2452-2
 1. Underwater photography. I. Title.
TR800.W8 1994
 778.7′3—dc20 93-23099
 CIP

*For Marjorie Bank, a marvelous
friend and teacher.*

CONTENTS

ACKNOWLEDGMENTS

Being able to make a living as an underwater photographer is a rare privilege, and it has happened only because of the support and generosity of the following people and institutions: The folks at Aqua Vision Systems, Camera Tech, Ikelite, Sea and Sea, Stromm, and Technical Lighting Control helped me select the equipment that I use most frequently. I owe great thanks to the people who have opened their homes and operations to me. Dr. John McCosker, Ed Miller, and the rest of the wonderful staff at Steinhart Aquarium in the California Academy of Sciences always made me feel welcome. Ron Holland and Borneo Divers hosted me in the very special islands of Sipadan and Sangalakki in Borneo, home of some of the best diving in the world. Robert Kane of Qantas Airlines in San Francisco and the Queensland Tourism and Travel Corporation sponsored a special trip to Australia. The Seychelles Ministry of Tourism sponsored two trips to their islands in paradise. Ken Knezick of Island Dreams Travel, Karen Sabo of Landfall Productions, and Bob Goddess of Tropical Adventures arranged excursions to various destinations around the world. In Florida, the staff of Homosassa Springs Park, Catquest, Save the Wildlife, and Back to Nature allowed me to photograph their special animals; and the Ellis family put up with me and my cohort with gracious hospitality.

My colleagues, friends, and family have been the best, and thanks goes to Bob Boller, Bob and Cathy Cranston, Steve Drogin, Lynn Funkhouser, Howard and Michele Hall, Lori Jackintell, Emory Kristof, Charles Lindsay, Mark Olson, Doug Perrine, Geoff Semorile, Helen Longest-Slaughter, Marty Snyderman, Joseph Stancampiano, Richard and Gayle Todd, Dan Walsh, and the entire Day family for their advice, help, and support over the years.

Judith Schnell and David Uhler at Stackpole Books were the guiding lights in the production of this book. Many thanks for their confidence in my work and their patience during the process.

INTRODUCTION

Underwater photography is in many ways easier than photography on land. For one thing, there are no mosquitoes underwater. Ambient light underwater is almost always the same color, blue. An underwater photographer can get up at a reasonable hour, spend his day gliding effortlessly above coral reefs, and end the day with a pleasant dinner with fellow underwater enthusiasts. The topside nature photographer doesn't have as much fun. He must rise before dawn, carry fifty pounds of gear, trudge through miles of snow or mosquito-infested swamp, and miss dinner for a solitary sunset. I know; I've been there. Compared to bird photography, with its flighty, flitty, tiny subjects and the requisite ultra-long, ultra-fast, megaton lenses, underwater photography is easy.

The quality of light underwater ends up making the range of techniques and equipment used in underwater photography very limited. In fact, this similarity of lighting equipment and technique has led some editors to say that all underwater photographs look alike. I disagree. The wealth of color and diversity of life underwater make the subject material unlimited in scope. Still, the color and direction of light underwater is nearly always the same, whether you are shooting in a brightly lit, warm coral reef or under the ice in Antarctica.

This book, rather than saying only nice, general things about photography and equipment, gives specific information, including both complaints and compliments about the products, the manufacturers, and their service. (Camera manufacturers don't like a critical approach to their gear, so send any contributions in care of the author, as I will be losing all those lucrative endorsements from the manufacturers). It also goes into detail on advanced techniques, since the basic techniques are covered adequately in other books and manuals. It simply presents the basics of photography, then moves on to such advanced topics as over/under photography, recharging batteries, and setting up a library. These advanced techniques and tricks of the trade have not been described in any other book on underwater photography, and they have been compiled only through years of experimentation and association with other professionals.

Throughout this book, I refer to such basic photographic ideas as shutter speed, aperture, depth of field, and film size. Terms and comparisons refer to 35mm cameras and lenses. Large-format cameras such as the Mamiya and Hasselblad have been used underwater, but I have not included them in this book. The basic principles of lighting and positioning remain the same whether you are shooting 16mm motion picture film or using a 6x7cm camera underwater.

This is an exciting time to be an underwater photographer; new and easier-to-use equipment is constantly being introduced, and the new electronic, autofocus cameras are making underwater photography almost foolproof. In a few years, portable HMI lights, which give a continuous daylight-balanced beam, may replace today's electronic strobes. The manufac-

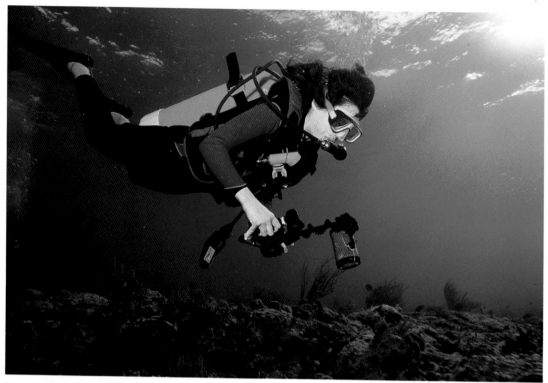

Diver Arietta Venizelos with underwater camera, Saba, Netherland Antilles. *Nikonos V, UW-Nikkor 15mm lens, Ikelite 150 strobe at quarter power, Kodachrome 64, 1/60 sec., f/5.6.*
Underwater photography is easy. It just looks hard.

turers of camera housings have worked closely with underwater photographers, which has resulted in elegant, optically correct underwater photography systems.

The very best underwater photographers are good, careful divers who are completely at ease with their gear and themselves in the underwater environment. Knowing the habits and behaviors of marine life contributes to making unique, salable photographs. Getting to know what you will encounter underwater and tailoring your equipment to a particular subject will give you the best results.

Light Underwater

Underwater photography is easy, though it looks hard. To take photographs of publishable quality, you must understand how water affects light. Three things happen when light goes underwater: Light rays are bent, or refracted; colors are absorbed; and light is scattered by particles in the water. This leads to the cardinal rule of underwater photography: Get close, and then get even closer. This rule makes the choice of equipment relatively simple. Nearly all photographs are taken with wide-angle lenses or close-up macro lenses, and nearly all subjects are lighted with strobes as fill or as key light. The properties of light in water affect your choices of technique and equipment.

Water selectively filters out colors from any light source. Yellows and reds go first, so that a photograph of a brilliantly colored angelfish taken only a few feet underwater can look drab. This means that to have color in an underwater scene, a light source must be placed close to the subject, or the photograph taken in water shallower than eight feet. Deeper than this, most underwater photographs become monochromatic, consisting of a blue background. There is no "golden hour" in underwater photography, as the warm tones of the setting sun never make it to any depth beyond eight feet. This makes things much easier for an underwater photographer, as he does not need to wake up for dawn light or miss dinner for sunset light. Photographs of colorful subjects more than six feet away from camera and light source are rarely taken, since color loss occurs as the light goes horizontally to and

from an underwater subject.

Light is diffused and scattered by the many particles in the water. Visibility underwater is never greater than one hundred and fifty feet at best and in coastal areas such as California

Basking shark feeding in plankton bloom, Santa Barbara, California. *Nikonos V, UW-Nikkor 15mm lens, no strobe, Koda-chrome 64, 1/60 sec., f/5.6.*

This photograph, taken in a plankton bloom, shows how particles in the water scatter and diffuse images. The plankton reduced visibility to less than three feet, making the resulting photograph muddy and unsharp.

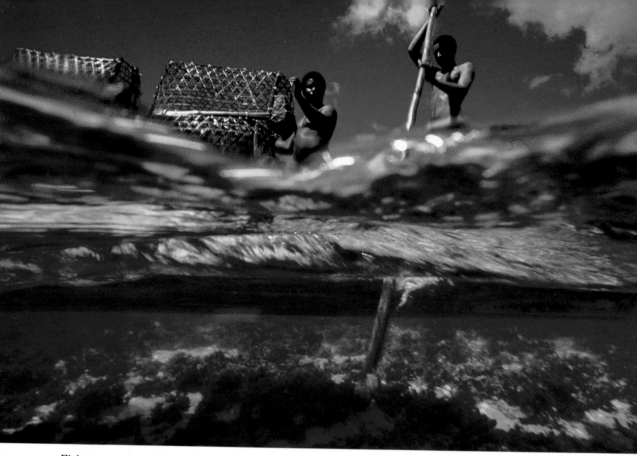

Fishermen, Seychelles Islands. *Canon F-1 in Oceanic housing, Canon 17mm lens with dome port and over/under filter, no strobe, Fujichrome 100, 1/60 sec., f/11.*

Light in water is refracted differently than in air. Thus, lenses used underwater must be matched to underwater-corrected ports, or the lenses themselves must be optically corrected. This type of photography is not possible with the underwater lenses made for the Nikonos cameras, which take blurry pictures out of water.

seldom amounts to more than sixty feet. Water, no matter how clear, contains particles that diffuse light and create unsharp images. Also, any lighting underwater is low in contrast. Light from a strobe is immediately softened by the diffusive property of water. Harsh sunlight from above becomes soft light underwater. Therefore, to get a sharp image of a subject the camera must be as close as possible. Thus the underwater photographer is limited to macro lenses or accessories such as extension tubes and diopters for close-up work and wide-angle lenses for large subjects.

Light is refracted differently in water than in air. This means that special underwater-corrected lenses must be used or normal lenses optically corrected to work underwater in a housing. Because of refraction, a lens's angle of view is narrowed. A 35mm lens underwater has the same effective angle of view as a 50mm lens on land. This means that the ultra-wide-angle lenses, from the 15mm or 16mm fisheye lenses to the narrower 24mm and 28mm lenses, are used to get closer to underwater subjects.

Photographer Mark Conlin with sea lion, Coronados Islands, Mexico. *Nikonos V, UW-Nikkor 15mm lens, no strobe, Fujichrome 100, 1/60 sec., f/5.6.*

I did not use a strobe in this photograph. The colors are muted, and shadow detail in the sea lion's face is almost too dark to be seen.

Photographer Mark Conlin with sea lion, Coronados Islands, Mexico. *Nikonos V, UW-Nikkor 15mm lens, Ikelite 150 strobe at quarter power, Fujichrome 100, 1/60 sec., f/5.6.*

In this photograph, taken only seconds after the one above, I added a tiny amount of strobe light to fill in shadows and bring back colors that were lost due to color absorption. The diver's drysuit is brighter and more colorful, and the sea lion's face shows up more clearly.

Juvenile jack in jellyfish, Coronados Islands, Mexico. *Canon F-1 in Oceanic housing, Canon 50mm macro lens with flat port, Kodachrome 64, 1/60 sec., f/11.*

In this photograph, I did not use strobe. The fish and jellyfish are lit only by the light of the sun, which has been robbed of its colors as it travels down through the sea. The resulting colors in the photograph are a monochromatic blue.

Juvenile jack in jellyfish, Coronados Islands, Mexico. *Canon F-1 in Oceanic housing, Canon 50mm macro lens with flat port, Oceanic 2001 strobe at full power, Kodachrome 64, 1/60 sec., f/11.*

In this photograph, I used strobe to bring out shadow detail and colors of the fish within the dark purple jellyfish.

The Fundamentals of Photography

Film
Format

Silver-based photography (as opposed to video or electronic still photography) relies on controlling and concentrating light from the subject to fall on the film, which is a mix of light-sensitive silver particles and dyes coated onto an acetate sheet. The size of this acetate sheet determines the film format. The most popular film format for underwater photography is 35mm, which gives a rectangular picture that is 35x24mm in length and width. Other film formats include the small, amateur 110 format, which is only one-fourth the size of 35mm film, and larger formats such as 6x7cm and 6x9cm. Film sizes can be as large as 4x5 inches or 8x10 inches, with correspondingly larger cameras. I can think of only one professional underwater photographer working with the medium-format 6x7cm system. All other professionals work with the 35mm camera system, which provides a compact camera giving thirty-six or more exposures per roll of film. Smaller film formats don't give the reproduction quality that 35mm is capable of, and larger format cameras are expensive, bulky, and specialized.

Print versus Transparency

You can get 35mm film in negative film and positive, or transparency, film. Color negative films are usually named with a suffix of "-color," such as Fujicolor, Kodacolor, and Ektacolor. Color transparency films, frequently called slides, are given names that end with "-chrome," such as Ektachrome, Fujichrome, and Kodachrome.

To see the results of negative film, it is necessary to print the film onto paper. The processed film itself has an orange cast and a negative image. Color transparency film, on the other hand, shows the resulting image immediately. The slide is viewed either by using a slide projector or by placing it on a light table. Because transparency film can be viewed as it is, with no intermediate step, it has become the preferred type of film for photographers and for publishers. Although color negative film has several advantages over transparency film, such as lower contrast and greater tolerance for exposure errors, nearly all professional photographers use transparency film. A plethora of transparency films are available, but only a few types of film are generally used in underwater photography: Fujichrome 50 or 100, Fujichrome Velvia, or Kodachrome 25 or 64. The choice of film is dictated by the type of shooting (close-up or wide-angle) and the amount of light available.

Characteristics

Speed. A film's speed, or ISO (formerly called ASA), is given as a number from 6 to 3200. A higher ISO number means that the film is more sensitive to light. Exactly what the numbers mean is not important; what is important is their values relative to each other. For example, a film rated at ISO 100 responds to light twice as fast as film rated at ISO 50, which

Flatworm on sea fan, Sea of Cortez, Baja California. *Nikonos IV-A, UW-Nikkor 35mm lens mounted on 1:2 extension tube, Aquaflash on full power mounted 7 inches from subject, Kodachrome 25, 1/90 sec., f/22.*

The subtle yet brilliant colors, sharpness, and fine grain of Kodachrome 25 film is almost unmatched. Unfortunately it requires so much light that its use is limited primarily to close-ups where strobes provide all the light.

in turn can register light levels twice as low as a film rated at ISO 25. Throughout photography, this concept of doubling or halving light levels or light sensitivity is used. Each double or half of a light level is called a stop. A film that responds to low light levels, such as Fujichrome 400, Kodachrome 200, or Ektachrome 1600, is called a fast film. A slow film, such as Koda-chrome 25, on the other hand, needs quite a bit of light in order to register an image. In general, the quality of film corresponds to its speed. The lower the speed of the film, the higher the quality of the image.

Grain Size and Sharpness. The grain of a film is the size of the silver grains and dyes in the film emulsion. In general, the finer the grain of the film, the better the photograph will look when it is enlarged for publication or blown up as a print. Slow films exhibit much finer grain than fast films and consequently can be printed in larger sizes before the grain shows up. Slow films also exhibit better color

School of mao-mao fish, Poor Knights Islands, New Zealand. *Nikonos V, UW-Nikkor 15mm lens, Ikelite 150 strobe at quarter power, Ektachrome 200, 1/60 sec., f/4.*

Hoping to show the background light in this cave, I used a fast film. The fish are illuminated by my strobe, which was set to the lowest power setting and further blocked by my hand. Nevertheless, the strobe's light provides all the light in the photograph. The limitations of a high-speed film are shown here: There is low color saturation and contrast, and the grain is large and noticeable.

saturation; colors are richer, deeper, and show up better as the photograph is enlarged. A film's sharpness does not necessarily correspond to its grain size or speed. For instance, Kodachrome 200 film is considered to be a sharp film, but it has large grain size.

Transparency films are divided into two types: Kodachrome (K-14) process; and E-6 type films, which include nearly every other kind of transparency film, such as Fujichrome, Ektachrome, and Agfachrome. Kodachrome film is very sharp and grainless because the K-14 process actually washes out all silver. The slightly grainier E-6 films use a less complicated

chemical process that couples silver grains with dyes on the film emulsion. Kodachrome film must be processed in laboratories equipped with machines that cost upward of $1,000,000. E-6 films, however, can be processed in a kitchen sink, and many resorts and live-aboard diving boats offer E-6 processing in two hours.

Kodachrome films have long been renowned for their archival properties. In proper storage—dark, dry, and cool—Kodachrome film and its dyes are supposed to last up to one hundred years. E-6 films traditionally have not had as good stability and in some cases have

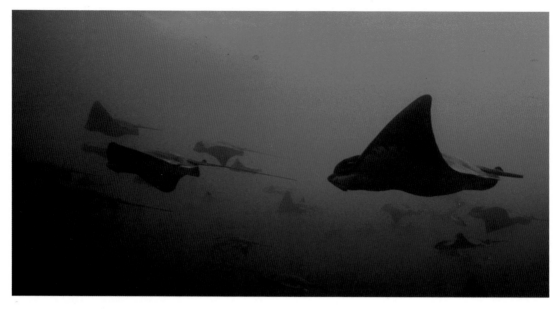

Bat rays, San Clemente Island, California. *Nikonos V, UW-Nikkor 15mm lens, no strobe, Fujichrome 100, 1/60 sec., f/2.8.*

In the fall, off islands and points of land off Southern California, huge schools of bat rays gather to mate and socialize. At twilight, these large rays rise off the sandy bottom and dance in a huge circle. Because the light was so low at dusk, I used Fujichrome 100 film, which was a mistake. This photograph is low in contrast and has always given printers problems in reproduction. Kodachrome 64 or 200 would have been a better choice in this case—the higher contrast would have made the rays pop out more from the intense blue background.

faded after as little as twelve years. The quality of the E-6 processing plays a big factor in the stability of the dyes in the film. The new Fujichrome Velvia film (an E-6 film) is reported to be as stable as Kodachrome film, and its sharpness and grain rival that of Kodachrome 25.

Contrast. A film's contrast is an essential part of its quality and determines its uses. Contrast is a difficult property to quantify or describe without looking at photographs. In every lighting situation, there will be a range of light and shadow values. In direct sunlight, the difference in light levels between the shade under a tree and the sunlight on grass in a field may be as much as 1000:1. This difference in light values between shadow and sunlight is called the contrast range. The human eye is able to see into shadow and full sunlight with no prob-

lem, but film's "exposure latitude" is different. Transparency film, under the very best conditions, can handle a contrast range of only 64:1 (six stops). Color negative film is better able to

Manta ray, Sangalakki Island, Borneo. *Nikonos V, UW-Nikkor 15mm lens, no strobe, Ektachrome Underwater film, 1/60 sec., f/5.6.*

This photograph of a manta ray was shot near the surface. Because of the red bias of this film, the portion of the water's surface at the top is objectionably reddish in color. The manta ray is also a bit more red than it looks in reality, but the water behind it looks fine.

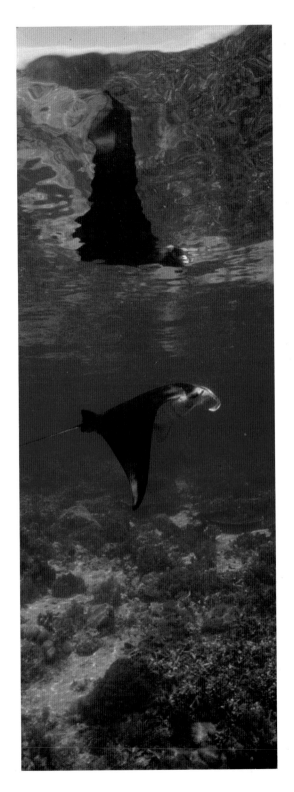

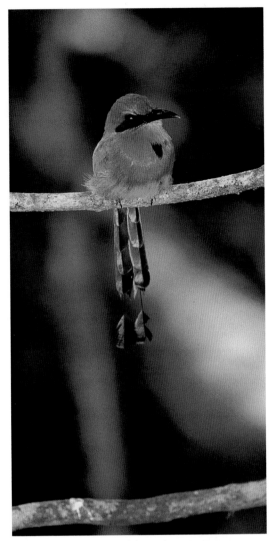

Rufous motmot bird, Panama rainforest.
*Canon T-90, Tamron 400mm lens, Sunpak
433AF strobe, Kodachrome 200, 1/30 sec.,
f/5.6.*

*Kodachrome 200 film is a high-speed, grainy
film which is quite sharp and color-saturated.
As a result, it can be used underwater in dark
situations with great success. This photograph
was taken in a rainforest, in dark conditions
similar to those found underwater.*

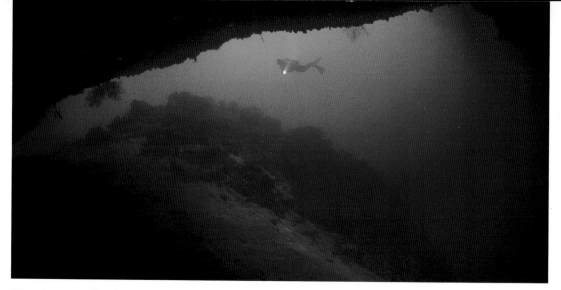

Diver in cave, Sipadan Island, Borneo. *Nikonos V, UW-Nikkor 15mm lens, no strobe, Ektachrome Underwater film, 1/30 sec., f/2.8.*

This shot was taken at the entrance to the Turtle Tomb of Sipadan Island, 70 feet down. At 70 feet, very little red or yellow color remains in the sunlight coming down from the surface. As a result, the use of Ektachrome Underwater film does very little for the photograph. The water color is intensely blue, which is a trait that all Ektachrome and Fujichrome films exhibit underwater.

Diver in cave, Sipadan Island, Borneo. *Nikon F4 in Aquatica housing, Nikon 16mm fisheye lens, no strobe, Kodachrome 64, 1/30 sec., f/2.8.*

Shot at the same time as the above photograph but with Kodachrome 64 film, this photograph shows the neutral color rendition of Kodachrome. The color of the water is not as intensely blue, and I would say that the shot is sharper and closer to reality.

handle wider contrast ranges, up to values of 256:1 (eight stops).

Some transparency films are more contrasty than others. For example, Kodachrome 64 film is contrasty compared to Fujichrome 100. In a sunlit scene, the shadow areas in a photograph taken with Kodachrome 64 will be a deep, jet black, and the highlights—light-colored areas—will often be washed out. The same scene on Fujichrome 100 will show shadow and highlight detail. High contrast can work for a photograph in certain situations. On overcast days, a high-contrast film will make scenes and faces pop out much more than a low-contrast film. Because underwater light is diffused and low in contrast, a high-contrast film such as Kodachrome 64 works well.

Color Rendition. Every film has its own color bias, or color rendition. For instance, E-6 films have traditionally had a cyan cast. Kodachrome films are noted for their good neutral color renditions—skin tones look nice and warm, and grays reproduce without color casts. The newer Fujichrome films have slowly been finding their way into the hearts of photographers and art directors, with their bright, saturated colors. They reproduce the green of grass especially well.

In 1993, Kodak introduced Ektachrome Underwater film. This film is heavily biased to reds in order to compensate for the color loss underwater. Unfortunately, in shallow water and when using strobe (without a compensating filter), this film makes everything, particularly white sand and skin tones, appear unnaturally red. This film is useful only when shooting wide scenics underwater which do not include the surface of the water. The film is slow at ISO 50, and the red bias simply makes no difference if you use it past 30 feet or so, since there is no red light anyway. In combination with this film, Tiffen Filters introduced two green-colored filters to put over your strobe. These filters allow the use of strobe on subjects without making them appear unnaturally red. My feeling is that this film is a bit too specialized. I don't want to bother with putting on filters underwater, and I often include the surface of the water in my shots. If I were really concerned about bringing back red colors in my shallow underwater shots, I would probably just bring down a red filter to put over my camera lens.

Choosing a Film

Each film gives a different image of a subject because of its contrast range, color rendition, and grain. Professionals often choose their film to match a particular set of lighting conditions or circumstances. (More often than not, though, the choice of film is dictated by what is available on the shelves of the local K-Mart.) For example, because of the good exposure latitude and nice blues and greens of Fujichrome 100, I use this film extensively in shooting topside subjects in sunlight. The photographs of the sea otter on the following pages show this adorable creature basking in full sunlight. The first photograph was taken on Kodachrome 64 film. Because of the high contrast and neutral color rendition of Kodachrome 64, the shadow areas have gone black and the water color is uninspiring. The second photo, taken on Fujichrome 100 film, is much more pleasing. The shadow areas show detail, and the water has a pleasant blue tinge.

Shooting underwater is a different story. Because of the blue color and diffused character of light underwater, Kodachrome 64 is a perfect choice. Its high contrast, sharpness, and neutral color rendition make underwater photographs sparkle. E-6 films, on the other hand, are not always the best choice for underwater photography, as they may accentuate the blue color of the water, making it look unrealistic.

I use the following films for various situations:
• Kodachrome 64 for wide-angle underwater shooting and for topside shooting on overcast days.
• Kodachrome 25, Fujichrome 50, or Fujichrome Velvia for close-ups.
• Fujichrome 100 for most topside shooting,

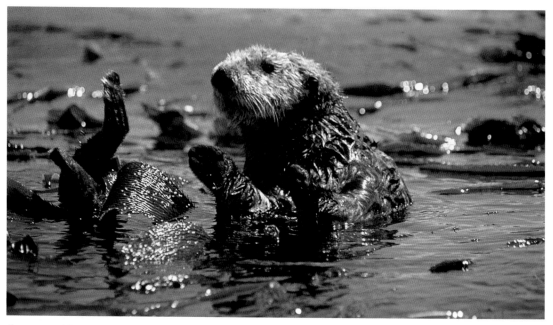

Sea otter, Monterey, California. *Canon F-1, Canon 70—210mm zoom lens, Kodachrome 64, 1/250 sec., f/8.*

Taken in bright sunlight, this photo shows a high contrast. The shadows are completely black and the water looks dull. Kodachrome film is ideal for low-contrast lighting situations—the very conditions found underwater.

especially in conditions of bright sunlight and scenics in which blue skies and green hillsides are dominant.

• Kodachrome 200 or Ektachrome 400 Plus film for shooting in low light. These are relatively new films based on a technology called T-grain. The color saturation and grain are phenomenal for such high-speed films.

Cameras

The cameras themselves are only a small part of the equipment used to take photographs. The 35mm film format is the choice of nearly every professional underwater photographer. Larger-format cameras have been used underwater, but in general, the larger size and cost of these cameras have prevented their widespread use by professionals.

Simple underwater housings and cameras can be found to fit almost any budget and style.

For vacationers, the plastic disposable cameras from Kodak and Fuji are somewhat waterproof down to ten feet or so. These cameras come loaded with film and a plastic lens, and one model even has a small flash unit off to the side. Unfortunately, great results can't be expected, since the lens is too narrow to allow you to get close enough to your subject, and light from the flash often is reflected back into the lens, a phenomenon known as backscatter. Backscatter is caused by light bouncing off particles in the water; this problem is solved by mounting the flash away from the lens.

Minolta, Canon, and other manufacturers have made small weather- and waterproof cameras with on-camera flashes and fixed lenses. The same limitations apply for these cameras. The Sea and Sea Motor Marine camera is a complete underwater system, featuring through-the-lens (TTL) flash, several different

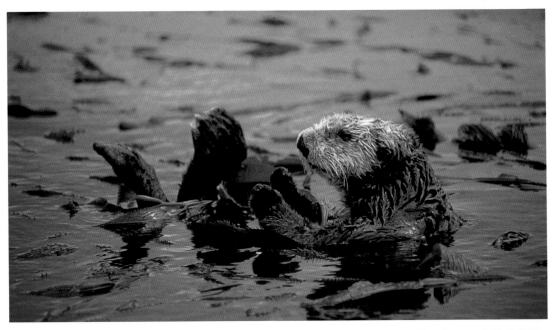

Sea otter, Monterey, California. *Canon F-1, Canon 70—210mm zoom lens, Fujichrome 100, 1/250 sec., f/11.*

This photograph of the same otter was taken only a few seconds later. The only difference is that I used Fujichrome film. The resulting photograph is more colorful and shows less contrast. The water has a pleasing blue cast and the shadow areas are more detailed. Fujichrome film, with its posterlike color renditions and tendency to cyan, is a good film to use in high contrast lighting situations—like bright sunlight.

lenses, and other accessories. Although its optics do not quite approach the quality of the Nikonos or housed SLR systems, the system's price and capabilities make it an appealing choice for all but the most serious underwater photographers.

Two basic types of 35mm cameras are available: The viewfinder-type camera uses a viewfinder that is separate from the lens for focusing and framing; the single-lens reflex (SLR) camera uses a mirror and prism to show you exactly what the lens is seeing. A viewfinder camera is more compact and makes less noise as the shutter is released, since it has no mirror to flip up as the picture is taken. An SLR camera, however, gives the very significant advantage of allowing you to see exactly what you are getting on film. The main problem with the viewfinder camera is the problem of parallax error, which is the difference in viewing area between what the lens sees and what you see through the viewfinder. The closer the subject is to the camera lens, the larger the parallax error.

Nikonos Cameras

The Nikonos amphibious cameras are complete underwater 35mm systems with lenses specially corrected for underwater use. The Nikonos V camera is perhaps the best model to date, featuring manual control, automatic exposure, and automatic TTL flash control in a compact unit. The lenses for the Nikonos mount quickly and easily with an O-ring-sealed bayonet mount. They range from a 15mm lens with a 90-degree angle of view to 20mm,

28mm, 35mm, and 80mm lenses. The only drawback to the Nikonos is that it's a viewfinder camera, not a reflex viewing camera. Consequently, parallax error and estimation of subject distance are major problems in close

Photographer Mark Conlin with Nikonos camera system, open ocean off San Diego, California. *Nikonos V, UW-Nikkor 15mm lens, Ikelite 150 strobe at quarter power, Kodachrome 64, 1/60 sec., f/5.6.*

The Nikonos camera with a wide-angle lens is perfect for taking photographs of larger subjects, such as this chain of salps.

situations. Since focusing and framing are always estimated with the Nikonos, macro subjects can be taken only with extension tubes or close-up diopters, coupled with framers. This arrangement works fine with subjects that can't swim away, but those that object to having framers placed over them are difficult if not impossible to photograph well with the Nikonos.

To solve these problems, Nikon introduced the new Nikonos RS in 1992, a complete underwater autofocus SLR camera system. This is a wonderful piece of technology incorporating the latest in autofocus and TTL flash technology, but it is bulky and expensive, and it lacks the versatility of a housed system. It has only a limited selection of lenses, including a 20–35mm zoom, a 28mm, and a 55mm macro lens. To be a better amphibious camera, the Nikonos RS should be scaled down in size and price, and it needs a wider lens comparable to the UW-Nikkor 15mm available for the older Nikonos models.

Throughout this book, when I refer to a Nikonos camera, I am referring to the viewfinder models such as the Nikonos II, III, IV-A, and V models. The Nikonos RS is so different from the other models that it cannot be lumped together with them.

SLR Cameras
An SLR camera in a housing solves the problems of the Nikonos but with added bulk, expense, and complexity. Some of the newer aluminum and ABS plastic housings are marvels of simplicity and functionality, allowing you nearly total control of the camera's functions in a small package.

The newer autofocus cameras, which use contrast to focus electronically, work just as well underwater as on land. The viewing system is critical, however, because your eye can be several inches from the viewfinder, behind the aluminum housing and your mask. Only a handful of SLR cameras are suitable for use in underwater housings. With top-of-the-line SLRs

Damselfish fighting for territory or a mate, Roatan, Honduras. *Canon F-1 in Oceanic housing, Vivitar 90mm macro lens with flat port, Oceanic 2001 strobe at full power, Kodachrome 64, 1/60 sec., f/11.*

A housed camera system is the only way to photograph small, active subjects such as these fish. By using a housing, you can focus on a tiny subject using long lenses that can isolate and pull in subjects to fill the entire frame.

such as the Canon F-1 and Nikon F2, F3, and F4, you can use enlarged prisms called sportfinders, Actionfinders, or Speedfinders, which allow your eye to be up to four inches away from the viewfinder while still showing the full image. They are the best means of focusing a camera encased in a housing. Unfortunately, Canon has abandoned its wonderful Speedfinder prism in the new EOS autofocus line, and Nikon's F4 is the only camera currently manufactured that accepts a sportfinder. The Nikon F4 with Actionfinder is expensive, costing up to four times as much as other autofocus cameras, and with the Actionfinder mounted, there is no matrix metering, which is a serious deficiency. Matrix, or multisegment, metering is a valuable feature in newer cameras; it can calculate cor-

Diver Lori Jackintell with housed camera system, Roatan, Honduras. *Nikonos V, UW-Nikkor 15mm lens, Ikelite 150 strobe at quarter power, Kodachrome 64, 1/60 sec., f/5.6.*

Housed cameras allow you to see and focus directly on the subject, rather than estimating distance and framing. The disadvantage comes in their added bulk and complexity.

15

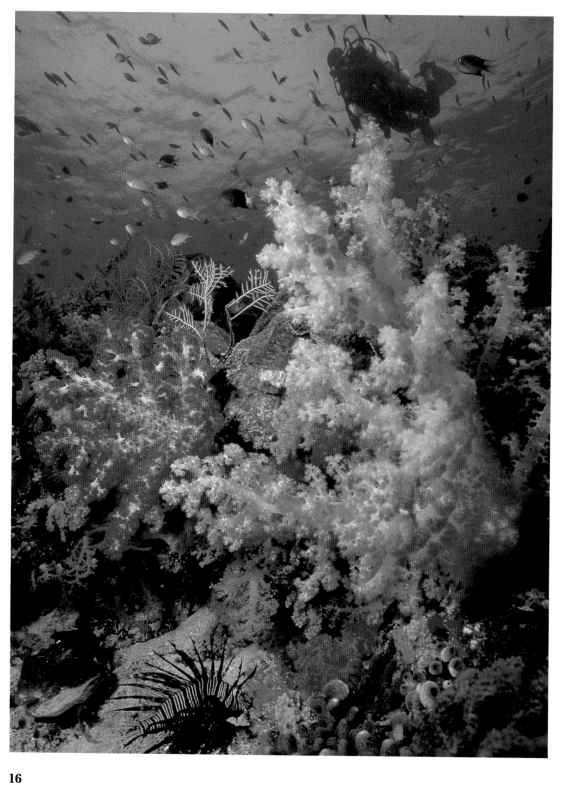

rect exposures in most situations.

Other SLR cameras can be fitted with magnifiers and alternate eyepieces to allow better viewing of the image. Stromm, a Canadian manufacturer, makes ABS plastic housings for the Nikon 8008s (called the F-801 in countries other than the U.S.) and N90 cameras. Their viewfinder is quite good—you can see the entire image. The housings are innovative, light, and tough, but they must be modified to allow aperture control. Ikelite Corporation makes Plexiglas housings designed to fit many cameras. The company's service record is excellent, and the housings can be taken down to two hundred feet. Aqua Vision Systems (from Canada), Subal (Austria), and Nexxus (Japan), have excellent aluminum housings for the Nikon 8008s and F4. The Nexxus housing for the F4 particularly shines; it fits the camera with Actionfinder like a glove and uses the smaller MB-20 battery pack rather than the bulky and unnecessary MB-21 motor drive pack sold in America with the F4. The Subal, Nexxus, and Tussey (U.S.A.) housings for the Nikon 8008s are also compact. None of these housings give adequate views of the image, however, which is the main reason for putting an SLR camera in a housing. The Aquatica 80 housing for the 8008s has a slightly better viewfinder, but your eye can't take in the entire frame at a glance. The Subal housing is a marvel of design, giving full functionality of the camera's controls. I have heard that an accessory viewfinder enabling full-frame viewing is on its way, which would make this housing one of the best available.

Lionfish and soft corals, Sipadan Island, Borneo. *Nikon F4 in Aquatica housing, Nikon 24–50mm zoom lens with Nikon 6T close-up diopter, Ikelite Ai strobe on half power, SR2000 slave, Kodachrome 64, 1/60 sec., f/5.6.*

By zooming in close on the lionfish, I was able to create a different composition than the one at left. This photograph was taken with the lens zoomed out to its narrowest focal length, 50mm.

Lionfish and soft corals, Sipadan Island, Borneo. *Nikon F4 in Aquatica housing, Nikon 24–50mm zoom lens with Nikon 6T close-up diopter, Ikelite Ai strobe on half power, SR2000 slave, Kodachrome 64, 1/60 sec., f/5.6.*

Being able to use a zoom lens underwater is a great boon. I was able to photograph this lionfish up close, among the soft corals, and then make this composition as well, by zooming the lens to a wider angle. Because the autofocus capability of the camera takes care of focus, the gear formerly used for focusing the lens can be used as a zoom control instead. This photograph was taken at the widest setting of the lens, 24mm.

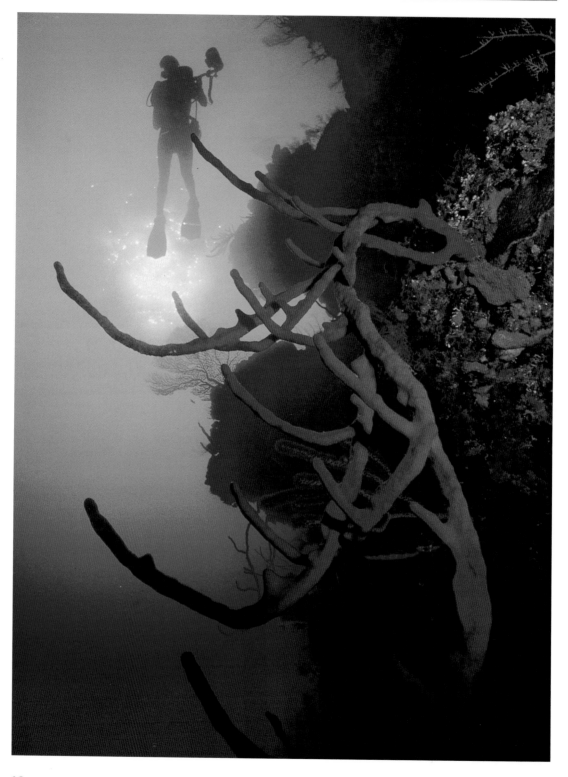

Lenses
Focal Length and Angle of View

A lens takes in light from a scene and focuses it on the film plane. Lenses vary in focal length, given in measures such as 100mm, 35mm, and 15mm. Lenses also vary in angle of view—the part of a scene included in the frame. The longer the lens, the narrower its angle of view, and vice versa. In 35mm photography, a "normal" lens sees approximately what the human eye sees, an angle of view of about 50 degrees. A wide-angle lens takes in more of a scene; these lenses range from the 16mm fisheye lens, with a 180-degree angle of view, to the commonly used 28mm and 35mm lenses, which have relatively narrower angles of view. Long lenses, often called telephoto lenses, range from 80mm to 1200mm. Because underwater photographers need to get close to their subjects, they usually work with wide-angle lenses and close-up macro lenses. The angle of view of a lens is narrowed underwater, because light rays are refracted differently in water than in air. Thus a 35mm lens underwater has about the same angle of view as a 50mm lens on land. For fish subjects, underwater photographers use 50mm and 100mm macro lenses from three inches to two feet away. For underwater scenics and larger subjects, such as a diver, shark, or coral reef, they use wide-angle lenses like the Nikonos 15mm from six inches to four feet away.

Diver and red rope sponges, Roatan, Honduras. *Nikonos V, UW-Nikkor 15mm lens, Ikelite 150 strobe at half power, Kodachrome 64, 1/60 sec., f/11.*

The great depth of field of wide-angle lenses such as the UW-Nikkor 15mm allows you to include sharp images of faraway divers as well as subjects as close as one to two feet away. This property of wide-angle lenses makes them ideal for prefocusing, to quickly snap off photographs of subjects, knowing they will be in an acceptable zone of focus.

Aperture and Depth of Field

Aperture refers to the size of the opening in the lens through which light passes to the film. Aperture values, or f-stops, are marked on the lens and usually range from f/2.8 to f/22. Each f-stop represents a doubling or halving of the light level that can pass through the lens. For instance, f/4, which is one stop greater than f/5.6, allows twice as much light to pass. The concept of apertures can be confusing. Just remember that a higher aperture number means a smaller hole through which light can pass. The speed of a lens is given as its lowest aperture value.

Depth of field refers to the amount of the picture in sharp focus. Standardized by manufacturers, the depth of field at given apertures is shown on most lenses. A photograph's depth of field depends on the aperture and lens angle: You get greater depth of field with a smaller aperture and/or a wider lens angle.

The sharpest photos are usually produced at apertures f/8 and f/11. Underwater, however, where light levels are much lower, this does not always hold true, and depth of field or shutter speed may be more critical. As a general rule, the highest aperture possible is used for close-up underwater photographs to get the greatest depth of field. In wide-angle photography, a shutter speed of 1/60 second or higher is favored over a small aperture.

The concept of depth of field is important, especially for users of Nikonos viewfinder cameras. With Nikonos cameras, all focusing and framing is done by estimation. Each lens shows the area of acceptable focus—the depth of field—as you adjust the lens's aperture and focus distance. Because these areas of acceptable focus have been worked out so well, the Nikonos camera with a wide-angle lens such as the UW-Nikkor 15mm f/2.8 is perfect for shooting quickly. There is no need to waste valuable time focusing on a fast-moving subject; the lens can be prefocused to photograph a subject within the zone of focus, which typically ranges from two to ten feet.

Close-up Equipment

One of a lens's most important features is its closest focusing distance. Macro lenses are specially designed to focus on small subjects. Some of the newer macro lenses allow you to focus onto areas as small as the film frame itself—a 1:1 reproduction ratio. Most older macro lenses are able to focus only to a 1:2 ratio, where the subject is rendered one-half lifesize on the film frame. Macro lenses are able to focus on small objects because their lens elements extend out farther than normal lenses.

An extension tube, merely a hollow tube of aluminum, enables a normal lens to focus on smaller subjects by bringing the lens out from the film plane of the camera. The only drawback is that the lens now cannot be focused on infinity. In underwater photography, almost the only application of extension tubes is with the Nikonos cameras along with framers.

Close-up diopters are pieces of glass specially engineered to magnify an image. Nikon and Canon make high-quality two- and three-element close-up diopters that fit onto the front of their own and other lenses. Almost all filter manufacturers make close-up diopter sets that come with +1, +2, and +4 diopters. The higher the diopter number, the greater the magnification. Diopters are used on certain lenses behind dome ports. Nikon and a few other manufacturers make diopters designed to fit over Nikonos 35mm and 28mm UW-Nikkor lenses in the water. Because the Nikonos is a viewfinder rather than an SLR camera, these close-up diopters must be used with a framer to indicate the picture area.

Ports

One of the most important features of a housing for a land camera is the range of ports available. Good housings have a choice of ports made of acrylic or glass through which the lens sees. Photographs taken through flat ports tend to be distorted because of the different refraction index of water. This "pincushion distortion" is most apparent if the scene contains straight lines; these will appear as curved lines bending in toward the center of the frame. There is less pincushion distortion with longer lenses. For this reason, wide-angle lenses are almost always used behind optically matched dome ports, which eliminate this problem. Shooting close-ups with a housed camera is usually done with longer 50mm to 100mm macro lenses behind flat ports, which also magnify underwater images.

A dome port on a housing in effect becomes a second lens, creating a second, "virtual" image in front of the dome. It is this virtual image that the lens must focus on. Because of this, a dome port must be matched to the wide-angle lens that will be used behind it. The virtual image of a subject at infinity is actually located at a distance that is twice the diameter of the dome. For instance, eight inches is a common dome size; this refers to what the dome's diameter would be if it were part of a sphere. The lens's nodal point, for best sharpness, should be located at the center of this imaginary sphere.

The nodal point of a lens is one of the least understood yet most important aspects of a housed system. For the purposes of this discussion, the nodal point of a lens is that point where light rays from the scene being photographed converge. The nodal point of a lens is

Anemonefish in anemone, Fiji. *Canon F-1 in Oceanic housing, Canon 50mm macro lens with flat port, Oceanic 2001 strobe at full power, Kodachrome 64, 1/60 sec., f/11.*

This photograph illustrates the shallow depth of field with longer lenses. The anemonefish in the front is in focus, but the one behind it, only a few inches away, is out of the zone of focus. By bringing my strobe closer and using a higher aperture such as f22, I could have increased my depth of field a bit, but probably not enough. Shallow depth of field is a constant problem with close-up photography.

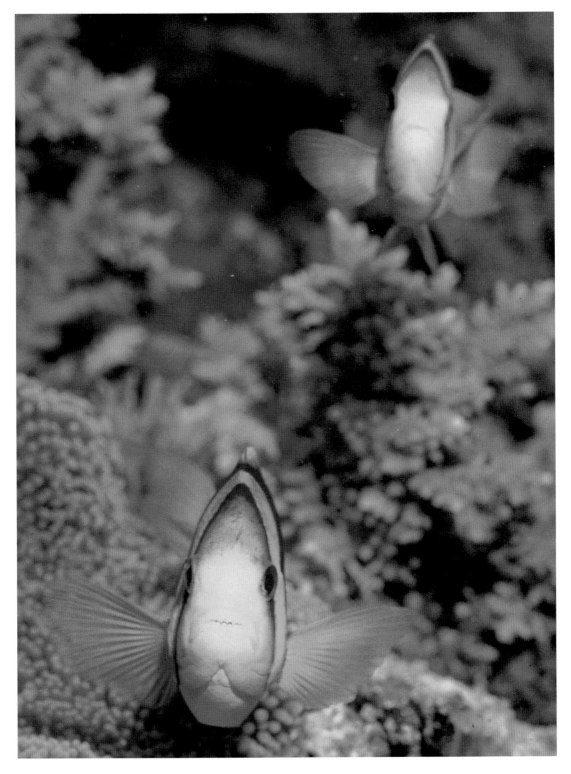

Flounder eyes, British Virgin Islands. *Nikonos IV-A, UW-Nikkor 35mm lens mounted on 1:2 extension tube, Aquaflash on full power mounted 7 inches from subject, Ektachrome 64, 1/90 sec., f/16.*
Some fish, particularly bottom dwellers that rely on camouflage to hide themselves, can be approached with framers. This flounder, which I found at night on a shallow sandy area, allowed me to put the framer of my extension tube right up to its face. Because the Nikonos with extension tube is such a compact unit, I was able to get below the flounder by pushing my camera into the sand. This made for a more dramatic composition.

usually at the iris, which is the place where interlocking flanges create the aperture. Every lens is different, however, and the nodal points of some lenses can even move back and forth during focus, especially with today's retrofocus designs for wide-angle and zoom lenses.

The virtual image of a shark swimming at infinity, or for underwater purposes twenty to thirty feet away, would be located at sixteen inches in front of the lens. Thus in this case the wide-angle lens must be able to focus at least as close as sixteen inches in order to capture the shark's image. If the shark is closer, the lens must be able to focus even closer than sixteen inches. Ideally, a wide-angle lens will focus within a range that includes the distance from the nodal point of the lens to the front of the dome (in this case, four inches) to twice the diameter of the dome (here, sixteen inches).

The larger the dome, the easier it is to find lenses that can focus down close enough. Additionally, a larger-diameter dome usually creates a sharper, more optically correct image. Close-up diopters are often used on wide-angle lenses for closer focusing ability. If a lens's nodal point is located farther from the camera than the dome is designed for, the dome must be brought out farther using a spacer. The Aquatica F4 housing for the Nikon F4 camera offers an eight-inch dome port that works well with the Nikon 16mm and 20mm lenses. The 18mm lens, however, has a nodal point that stands out nearly an inch farther than the other lenses. With this lens, in order for the dome port's center to intersect the nodal point, a one-inch spacer must be placed behind the dome so that center of the dome sits farther out.

A wide-angle lens that is not centered cor-

rectly or is not matched properly with a dome will produce blurry or distorted photographs. Many camera housings are not designed with these considerations in mind, or their tolerances are not tight enough to give the precision demanded by wide-angle shooting. A photograph that is not optically correct will often be sharp in the middle of the frame but blurry and distorted around the edges. Manufacturers of newer housings like the Aquatica have used input from organizations such as the National Geographic Society to match their domes with specific lenses from different manufacturers.

The above explanation of domes is only an approximation of what is actually needed to match a dome with a wide-angle lens. The equation for calculating the virtual image distance is a bit more complicated than simply twice the diameter. Another problem is field curvature, which is caused by the dome port itself and becomes worse with smaller domes. Diopters may improve or worsen this effect.

Flash

Underwater light sources include sunlight (ambient light) and man-made light. The only practical source of man-made light is an underwater flash, or strobe unit. Since warm colors are absorbed underwater, any photographs taken below eight feet have a strong bluish cast. To capture the brilliant reds and yellows of the underwater world, most photographers use strobes. Water scatters light, rendering the harshest strobe into a soft, pleasing light. Topside photographers must use bounce flash, softboxes, and umbrellas to get the same diffused quality from their strobes.

Strobes come in all sizes and shapes. The two features important for underwater photography are the strobe's beam angle and power, expressed by its guide number. The beam angle of a strobe, given in degrees, indicates the size of the circle of light it emits. It can be compared to the angle of view of a lens. For instance, many small strobes are quoted as having a beam angle equivalent to the Nikonos 28mm

lens, about 40 degrees. These are relatively narrow beams. The Ikelite 150 strobe, used extensively by many photographers for wide-angle work, has a beam angle of 110 degrees, which covers the angle of view of the Nikonos 15mm lens with room to spare. The Oceanic 2001 strobe, with a beam angle of 85 degrees, can create a circle of light resembling a spotlight around the subject if used with a 15mm lens, which has a wider angle of view than the strobe.

Just about all strobes I've tested have the same intensity. The bigger strobes need bigger batteries and electronics so that the equivalent amount of light is spread over a wider area. Strobes with narrower beam angles can get by with less battery power and smaller sizes. At three feet, however, both large and small strobes usually give the same aperture reading:

Diver and bumphead parrotfish school, Sipadan Island, Borneo. *Nikon F4 in Aquatica housing, Nikon 16mm fisheye lens, no strobe, Kodachrome 64, 1/60 sec., f/5.6.*

This photograph shows the problem of field curvature, which is created by using a super-wide lens behind a dome. Subjects at the far ends of the frame are distorted and elongated unnaturally because of this optical problem. The solution is to keep divers and other subjects away from the edges of your photographs.

f/8 underwater with ISO 64 film. This translates to a guide number of about 24 for ISO 64 film. The difference between the large, heavy strobes and the small, lightweight strobes is not in the intensity of their light but in the area they can cover.

Photographers using manual flashes have traditionally relied on guide numbers for determining exposure with strobe. A typical strobe may have a topside guide number of 100 (indicating the number of feet at ISO 64). Dividing the guide number by the distance to the subject will give you the aperture needed for a correct flash exposure. For example, a typical guide number for an underwater strobe is 22. For a subject three feet away, an aperture of f/8 will give you the proper exposure with this strobe. Manual flashes often have a control for their

Diver with triton trumpet snail, Kona coast, Hawaii. *Nikonos V, UW-Nikkor 15mm lens, Oceanic 2001 strobe, Kodachrome 64, 1/60 sec., f/5.6.*

In this photograph I used a strobe with a beam angle that was narrower than my lens. The falloff of light on the right side of the photograph is noticeable. Using a narrow beam strobe can create a circle of light in a photograph, and this hotspot can sometimes make a photograph more dramatic. Other times a hotspot can ruin a photograph. It all depends on what effect you are trying to achieve.

intensity in stops. The Ikelite 150 strobe, a popular wide-beam unit, has settings for quarter, half, and full power.

TTL Flash

A TTL-controlled flash is a miracle of electronics. Unlike older automatic flashes, which relied on separate sensors and didn't work very well, the TTL flash system actually senses and measures the amount of flash coming through the lens. When the camera senses that enough light has come through the lens for a proper exposure, it switches off the flash. The light from the flash is measured as it comes through the lens in real time, so you are still guaranteed a proper exposure if you add filters or change lenses or distance. However, the TTL metering system can be fooled in certain situations, particularly in cases where the subject is small within the frame. The camera senses light from the flash by metering the light reflected off the film, so it is important to load film before testing whether a TTL system is working.

Photographers choose their strobes according to the type of photography they will be doing. Large, bulky strobes with wide beam angles are suited for shooting with wide-angle lenses, whereas small strobes with narrow beam angles are good for close-ups. Two small strobes can often do the same job as one giant strobe. TTL flash control works well in underwater systems, especially with close-ups. Ikelite, Sea and Sea, Nikon, and other manufacturers make TTL-compatible underwater strobes; these can be used with the Nikonos V as well as the Nikon 8008s, N90, and F4 cameras in housings.

A slave strobe is often used in tandem with another strobe to fill in shadows. The slave strobe has a sensor that causes it to trigger upon sensing light from the other strobe.

A problem in underwater photographs lit by strobe is backscatter, which is caused by particles in the water reflecting the light. The more particles in the water, the worse the backscatter. Backscatter is reduced by aiming the

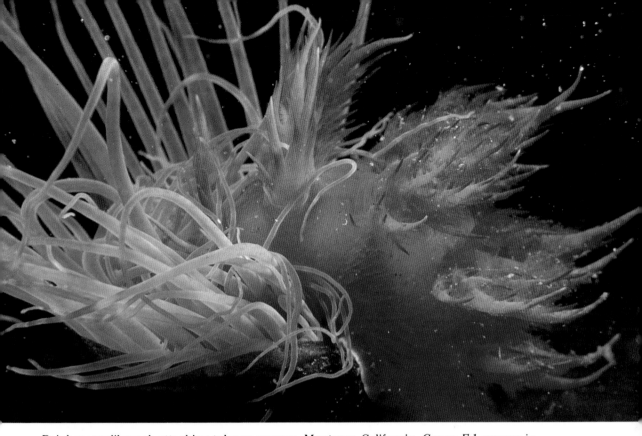

Rainbow nudibranch attacking tube anemones, Monterey, California. *Canon F-1 camera in Oceanic housing, Canon 50mm macro lens with flat port, Oceanic 2001 strobe at full power, Kodachrome 64, 1/60 sec., f/11.*

After I took the photograph below, I moved closer to the subjects. I was able to aim my strobe at a higher angle, thus reducing the backscatter. I was not able to completely eliminate the problem, but the overall effect was much improved.

Rainbow nudibranch attacking tube anemones, Monterey, California. *Canon F-1 in Oceanic housing, Canon 50mm macro lens with flat port, Oceanic 2001 strobe at full power, Kodachrome 64, 1/60 sec., f/11.*

This photograph was taken in a silty area. The silt clouded the water with my slightest movement, and passing sea lions delighted in dive-bombing me as I waited for the water to clear. This photograph shows a significant amount of backscatter, which was caused by the silty particles in the water reflecting the light of the strobe back to the lens. The resulting photograph is muddy and uninteresting.

Diver over table corals, Philippines. *Nikonos V, UW-Nikkor 15mm lens, Ikelite 150 strobe at half power, Kodachrome 64, 1/60 sec., f/5.6.*

Using a slave strobe, which senses light from another strobe and triggers itself, adds much to an underwater photograph. In this photograph, the diver is holding a slave strobe that was triggered by the light from my flash on my camera. The beam of light from an ordinary flashlight would not have shown up in this photograph. Floodlights and video lights on the order of one hundred watts and more can show up on a photograph, but 1/60 second is just too fast a shutter speed for the ordinary underwater lights used by most divers.

strobe so that its cone of light hits the subject and not the water in front of the subject. Aiming the strobe at a high angle or a strong side angle from the lens will solve this problem. Also, the smaller the lens aperture, the less backscatter will register on the film, because the strobe light reflected by particles is relatively less intense than that reflected by the subject.

Fill Flash versus Primary Flash

Key, or primary, light refers to the chief light source or sources for a photograph. When a strobe is used to provide most of the light in a scene, that strobe is being used as the key light. In this case, the background is usually black and the subject harshly lit. A more professional approach to lighting uses flash as a fill light; here, the flash complements ambient light in the background and is used to fill in shadows on the subject rather than provide all of the exposure. The most subtle, powerful photographs use flash as fill. These photographs gain their power through a well-lit subject against a visible and dramatic background lit by ambient light. This use of strobe light as a fill is known as

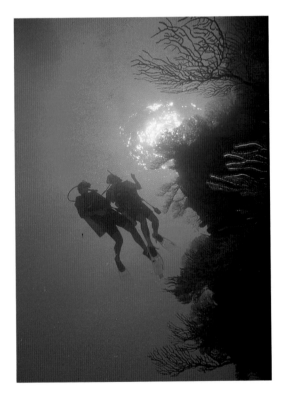

Divers on coral wall, Grand Cayman Island.
Nikonos V, UW-Nikkor 15mm lens, no strobe, Kodachrome 64, 1/60 sec., f/5.6.

This photograph shows the reef and divers as silhouettes. No strobe was used.

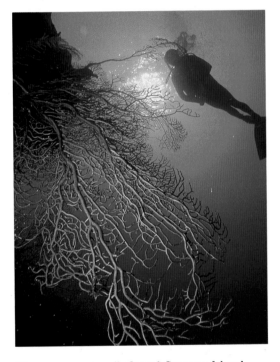

Diver on coral wall, Grand Cayman Island.
Nikonos V, UW-Nikkor 15mm lens, Ikelite 150 strobe on quarter power, Kodachrome 64, 1/60 sec., f/5.6.

This photograph shows a sea fan on the reef wall lit by strobe, thus bringing back its red colors. The diver is still a silhouette, as he was too far away to be lit by my strobe.

Diver Henry Kaiser in kelp forest, Monterey, California. *Nikonos V, UW-Nikkor 15mm lens, Ikelite 150 strobe on quarter power, Kodachrome 64, 1/60 sec., f/2.8.*

In this photograph, I attempted to show the background of kelp behind the diver, and opened up my lens' aperture to its widest setting. I brought down the power of my strobe and put my hand over it to further lessen its output, to better balance the two light sources. The resulting photograph shows a diver within the background of a kelp forest, arguably a more interesting picture than the one at left.

Diver Henry Kaiser in kelp forest, Monterey, California. *Nikonos V, UW-Nikkor 15mm lens, Ikelite 150 strobe on full power, Kodachrome 64, 1/60 sec., f/8.*

A kelp forest is often very dark. In this photograph, I did not even try to show the ambient light behind the diver. Strobe provided all of the light in this photograph, and the background is completely black.

balancing ambient light with strobe. It is a very simple technique to master, but first you need to understand the difference between ambient and strobe light.

Ambient light is almost always light from the sun. Since ambient light is continuous, it registers an exposure on the film for the full period of time the shutter is open. Strobe light, on the other hand, lasts for only 1/2000 to 1/10,000 second. Because it is so quick in duration, the intensity of strobe light is unaffected by shutter speed. The effect of strobe light on the exposure can be controlled by the lens aperture setting and by moving the strobe closer to or farther away from the subject.

Effective wide-angle underwater photographs are nearly always achieved by using strobe light as a fill. Underwater, the use of a fill flash also brings back colors that would other-

wise be lost to water absorption. The photographs on page 27 will serve to illustrate this point. The first photograph shows a pair of divers on a reef. The exposure is correct, since the water appears blue in the photograph, but both the divers and the reef are black silhouettes. In the second photograph, the strobe has placed sufficient light on the reef to show its true colors. The diver, however, is too far away to be lit by the strobe and is still a silhouette.

Fill flash works the same way whether used underwater or topside. For a typical underwater shot, I meter ambient light at my strobe sync speed—the fastest shutter speed that allows the flash to cover the entire frame. Most older manual cameras allow a maximum flash sync speed of 1/60 or 1/90 second, while the newer electronic cameras allow 1/125 or 1/250 second. My usual shutter speed underwater is

1/60 second, and in typical waters this gives me an aperture value of f/5.6 or f/8 with ISO 64 film. This is the ambient exposure—that which governs the background in a photograph. Using these settings for my wide-angle photographs will give me a nicely exposed background of blue water.

In using flash as fill light, my ambient exposure determines my aperture setting, so distance from the subject may be the only way I have to control the amount of light from the flash that the subject receives. Many manual flashes, however, have different power settings that allow you to control the amount of light from the flash. In most cases, especially underwater, the ability to manually turn down a strobe to lower power settings is better than moving farther away from the subject.

In using manual flashes, the light from the flash must match or be slightly less than the ambient light. This gives a touch of light on the subject, bringing out the colors and eliminating shadows. The ambient exposure is governed by aperture and shutter speed. On land, the most dramatic photographs are often taken during low-light periods such as dawn or dusk, by mounting the camera on a tripod, using a slow shutter speed, and exposing the foreground with strobe fill.

The newer electronic cameras take the calculations out of using fill flash. The best newer cameras talk back to their strobes, giving correct exposures in almost every situation. Matrix, or multisegmented, metering in Canon and Nikon cameras automatically governs flash power, cutting off the flash when a subject has received enough light. With older electronic cameras, using fill flash may be a problem. For instance, I sometimes use a Canon T-90 with very basic TTL metering. In instances where the subject does not fill the frame, the camera is fooled into putting out much more strobe light than is necessary. This happens because the meter is watching for enough light bouncing off the subject to make a correct exposure. If the subject does not fill the frame, then light from the flash disappears into the background instead of bouncing back to the meter, the flash puts out much more light than necessary, and the subject is overexposed. There are ways to get around this, however. I simply judge the amount of space my subject fills in the frame, then I bracket by using the exposure compensation dial.

This technique was used to photograph a parrot at sunset. The parrot was on a perch along a boat, with an island in the background. My ambient exposure indicated an aperture of f/2.8 at a 30th of a second. Since the parrot filled less than one-quarter of my frame, I set the exposure compensation dial to quarter power. This made the camera shut off the flash much sooner than it otherwise would have. I also bracketed heavily, using the exposure compensation settings of one-eighth and half power.

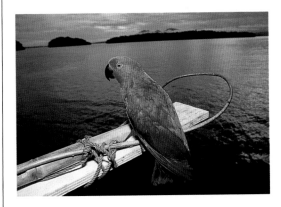

Parrot at sunset, Solomon Islands. *Canon T-90, Canon 24mm lens, Sunpak 433AF strobe, Kodachrome 64, 1/30 sec., f/2.8.*

The low light levels of sunset and sunrise make fill flash a preferred method for bringing back color and detail in shadows. In this photograph, I tried to put out just enough strobe light to show the parrot's true colors. Had I not used fill flash, the parrot would have been a silhouette.

29

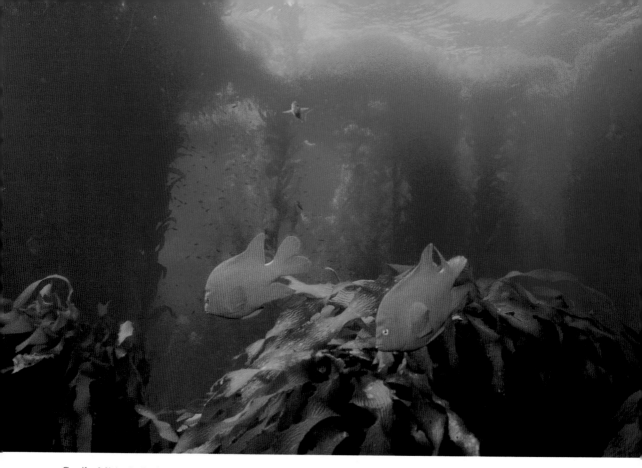

Garibaldi in kelp forest, San Clemente Island, California. *Nikonos V, UW-Nikkor 15mm lens, Ikelite 150 strobe on quarter power, Kodachrome 64, 1/60 sec., f/4.0.*

Wide-angle photographs that show an animal in its habitat make for powerful compositions. Making these photographs requires an understanding of the difference between ambient light and strobe fill. I metered the water behind the garibaldi to determine my ambient light setting, which was 1/60 second at f/4. This setting rendered my background of kelp forest properly. I then adjusted my strobe to its lowest power setting so that it would add just enough light to bring out the colors of the fish.

The newer generation cameras, such as the Canon EOS series and the Nikon autofocus cameras, do everything when they are coupled with dedicated strobes that talk directly to the camera. Their metering systems are smart enough to compensate for situations in which the subjects don't fill the frame, and they are able to fill in shadows with flash automatically.

Balancing strobe light with ambient light is one of the most critical techniques you can master. The most important thing to remember is that you can control the amount of light the subject receives either by moving the strobe closer to or farther from the subject or by choosing different manual power settings. The aperture and shutter speed are dictated by the ambient light, and the strobe light must be adjusted to the aperture selected. The newer automatic, TTL-controlled flashes work well in many cases but can be fooled by subjects that fill just a small part of the frame. In practice, I

shoot most of my wide-angle, balanced exposures using manual flash. In close-ups where the subject fills the frame, TTL-controlled flash usually works fine.

Exposure

Proper exposure of film depends on manipulating two separate values: shutter speed and aperture.

Shutter speed is the length of time that the camera's shutter stays open, often ranging from 30 seconds to 1/2000 second. In most cases, it is set by rotating a dial on top of the camera body. Shutter speeds are usually set in stops, as are apertures and film speeds. A shutter speed of 1/60 second allows twice as much light to pass through to the film than a shutter speed of 1/125 second. A fast shutter speed such as 1/250 second can stop motion, whereas a slower shutter speed such as 1/15 second will blur motion.

Since shutter speed and aperture control the amount of light that can reach the film, you can control exposure by manipulating them. The values a photographer chooses are often a compromise between a small aperture to get great depth of field and a high shutter speed to stop motion. Both shutter speed and aperture can be halved or doubled, so the same amount of light can be allowed to reach the film with different combinations of shutter speed and aperture settings. For instance, a typical exposure on a sunlit coral reef using ISO 64 film is f/5.6 at 1/60 second. The same amount of light would also reach the film with an aperture of f/8 and a shutter speed of 1/30 second, or with an aperture of f/4 and a shutter speed of 1/125 second. The slowest shutter speed that should be used underwater is 1/60 or 1/30 second. Shutter speeds slower than that result in blurred photographs from hand or body movement.

A good general rule of thumb relating aperture, film speed, and shutter speed for topside photography is "the sunny f/16 rule": In sunny conditions, anywhere in the world, if the shutter speed is set at the inverse of the film speed,

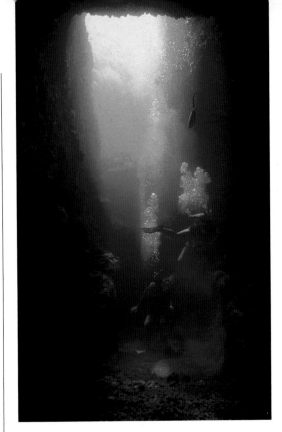

Divers in coral cave, British Virgin Islands. *Nikonos V, UW-Nikkor 15mm lens, no strobe, Kodachrome 64, 1/30 sec., f/2.8. Light was so dim in this cave that I was forced to use a shutter speed of 1/30 second. This is just about the slowest speed I can use without blurring the photograph with the movement of my hand. Even so, the divers' movements are blurred by the show shutter speed. The only solution to this situation is to use a higher-speed film or an underwater tripod.*

then for correct exposure the aperture should be set at f/16. For instance, if shooting Kodachrome 64 in direct sunlight with a shutter speed of 1/60 second, use an aperture of f/16 for proper exposure. Like all rules, this has its exceptions, but it is a remarkably accurate standard. When light enters water, however, it generally loses two to three stops. Thus a good starting point for ambient light exposure underwater could be called the "sunny f/8 to f/5.6 rule."

A Look Inside My Camera Bag

Over ten years of underwater photography, I've spent thousands of dollars on such seemingly trivial items as strobe arms and battery chargers. I've watched other photographers dump seven-hundred-dollar movie tripod heads into salt water on purpose and have myself flooded four cameras, lost one Nikonos in the bottomless depths of the Greenland Sea, and ruined at least five strobes by failing to seal them or charge them properly. I've experimented, learned from my mistakes and those of others, and then spent even more money. I've been on large boats and small boats all over the world, traveled through the most nefarious of airports, been scrutinized by the most corrupt of customs agents, and had to pay more for my excess baggage than for my airfare.

In this chapter I will try to pass on my accumulated wisdom from ten years of paying for the chance to throw thousands of dollars worth of precision camera gear into salt water. These tricks of the trade are invaluable when you're working in the field. By the way, most of my decisions to purchase gear have been made only after studying the options carefully. Camera manufacturers, contrary to popular belief, never give photographers free deals on gear. The following paragraphs describe the camera gear I take on a typical trip.

I carry two trusty and compact *Nikonos V bodies* wherever I go, along with a 15mm lens for quick shots of large animals and scenics that are generally three feet or more away. At three feet, parallax error is negligible, and the small size and ease of using the Nikonos make it a wonderful unit. The *UW-Nikkor 15mm lens* is the most frequently used lens of all my gear and probably the sharpest wide-angle lens ever made for underwater use. A Nikonos body plus the 15mm lens and a wide-beam strobe are unbeatable for photographing large, fast-moving animals. The 15mm lens requires a large accessory *DF-10 viewfinder* in order to show the picture area, as the viewfinder on the Nikonos body is inadequate.

I also carry *UW-Nikkor 20mm, 28mm, and 35mm lenses*. The 20mm lens gives a slightly narrower view of underwater scenics, and it allows me to photograph large animals I can't get close to. A Nikonos body with this lens is small enough to slip inside my BC pocket. The

School of glassfish in coral cave, Red Sea. *Nikon 8008s in Stromm housing, Nikon 24mm lens with + 2 diopter, Ikelite Ai strobe on TTL, SR2000 slave strobe, Fujichrome 100, 1/60 sec., f/4.*

Being able to focus and compose a scene through a reflex viewing camera is imperative when you are working close to your subjects. I was able to compose this scene and place the elements of the photographs exactly where I wanted them to appear in the frame. With a viewfinder camera such as the Nikonos, I would not have been able to achieve as precise a composition. The combination of lens and diopter that I used for this photograph also allowed me to photograph fish less than four inches away from my port.

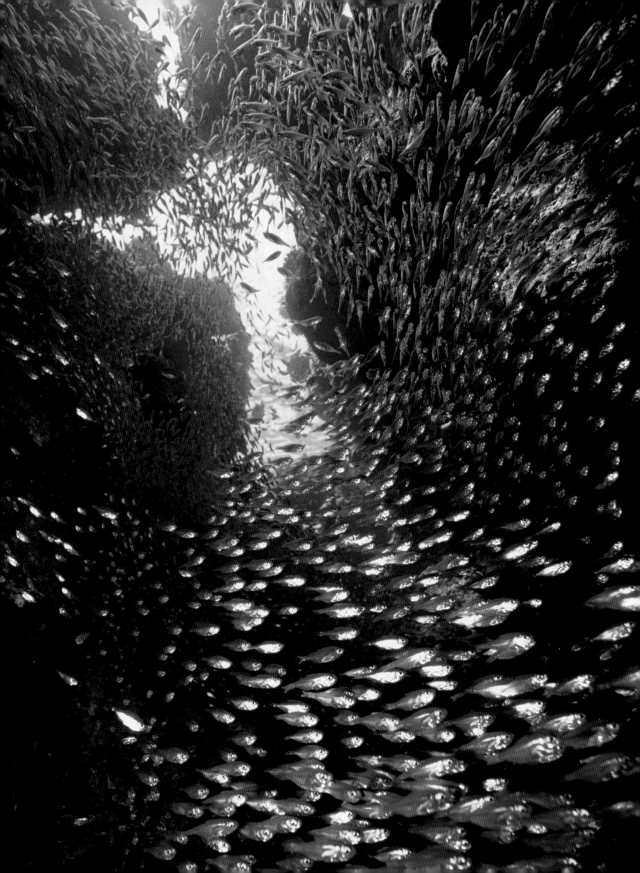

28mm lens gives an even narrower field of view and allows me to photograph large, skittish subjects from far away. I use the 28mm and 35mm lenses with a *Nikonos close-up kit and extension tubes* for fast, easy close-ups with framers. This combination plus a TTL flash is hard to beat for ease of use. (Note: I do not recommend carrying a Nikonos with 15mm lens in a pocket; the 15mm lens is large and unwieldy and may be tipped out of its O-ring seat.)

When precise focusing and framing are required, I use an SLR camera in a housing. For macro work, I've settled on two modified *Stromm housings* with *Nikon 8008s bodies* and *Nikon AF 60mm and 100mm macro lenses* inside the housings, along with matching flat ports. The Nikon 8008s body is an inexpensive autofocus camera that does the job, although just barely. The Stromm ABS plastic housing is wonderfully light and tough, and I can carry it on a backpacking trip if need be; however, it lacks the proper controls and precision for shooting wide-angle well. The staff at Camera Tech in San Francisco modified the basic housing so that aperture can be changed under-

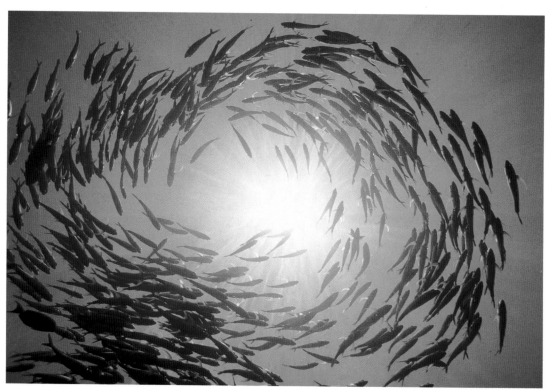

Schooling jacks swimming in a circle, Sipadan Island, Borneo. *Nikonos V, UW-Nikkor 20mm lens, no strobe, Kodachrome 64, 1/125 sec., f/8.*

The Nikonos with a wide-angle lens is ideal for taking shots of large subjects that are more than three feet away. At this distance, what you see in the viewfinder is very close to what the lens actually sees. I was snorkeling over this school of jacks, which are found right off the dropoff at Sipadan Island, and the small size of the Nikonos made it ideal for free-diving.

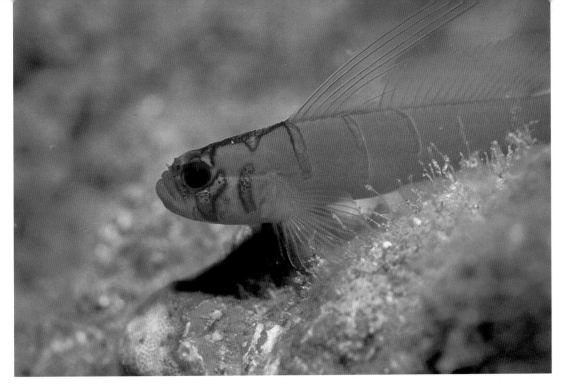

Red-banded goby, Catalina Island, California. *Canon F-1 in Oceanic housing, Vivitar 90mm macro lens with flat port, Oceanic 2001 strobe at full power, Kodachrome 64, 1/60 sec., f/11.*
This was one of my first experiments with a lens that actually was able to focus down to 1:1. I had always wanted to photograph these tiny gobies well, but my standard macro lens at that time could only focus down to 1:2, which rendered these gobies too small in the frame. I wanted to fill the frame with this fish's colorful body, and I was able to do so with the combination of a long macro lens which could focus down to life size.

water, an essential capability. Shutter speed, however, must be preset on land. The housing does offer TTL flash and matrix metering and is perfect for macro shooting at a set shutter speed of 1/60 to 1/250 second. The Nikon macro lenses both focus down to 1:1—much better than macro lenses from most other manufacturers, which can only focus down to 1:2. Manual focus is impossible with the Stromm housing, but the housing has a magnetically coupled shutter release switch that allows the camera's autofocus system to take over.

The 8008s camera uses standard AA batteries, which are available in rechargeable nicad. (I greatly prefer equipment that uses AA batteries.) I select my gear with as much thought to

their battery requirements as to their other features, and I greatly prefer equipment that can be operated off AA size batteries. The main problem with the 8008s body is that it doesn't show 100 percent of the picture area. Also, its prism is not removable, so for viewing underwater you need special optics and magnifiers, which never do the job as well as a sportfinder. Nevertheless, the Stromm accessory viewfinder-magnifier, which is screwed onto the 8008s's eyepiece, offers adequate viewing of the entire frame at one glance. This is the best viewfinder for the 8008s camera on the market.

For underwater scenics that require careful composition, I use an *Aquatica 4 housing* with a *Nikon F4s body* and *Actionfinder* inside and

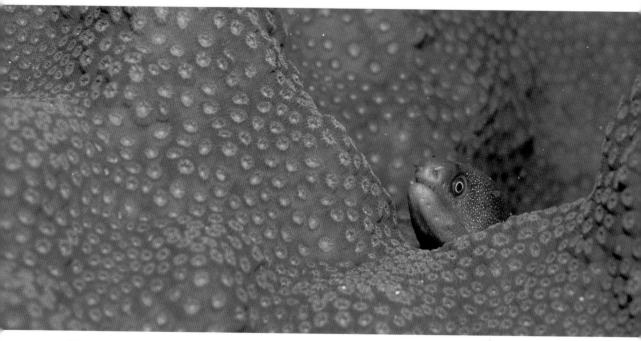

Shy moray eel, Roatan, Honduras. *Canon F-1 camera in Oceanic housing, Canon 50mm macro lens with flat port, Oceanic 2001 strobe at full power, Kodachrome 64, 1/60 sec., f/11. Shy subjects such as this moray eel will retreat into their holes if approached with a framer. With a housed SLR system, photographs of these shy animals can be taken easily.*

wide-angle lenses ranging from fisheye to 24mm. The housing is much larger and heavier than it needs to be, but it is versatile and the space inside allows such amenities as extra strobe fittings. I even have the option of triggering this camera remotely by attaching an underwater pluggable cord to one of the connectors in the housing. The viewing through this system is superb, bright, and quick—ideal for shooting wide-angle, where focus is critical and often hard to do. The Aquatica housing has gearings to control focus and aperture. In general, I don't use autofocus when shooting wide-angle. Trying to use autofocus on subjects such as a school of small minnows inside a cave is nearly impossible. Autofocus also breaks down when attempting to photograph large subjects that have little contrast or silhouettes of animals such as turtles and seals. Zoom lenses can

be used with the Aquatica housing, as the autofocus capability frees up one gearing unit to control zoom.

Autofocus

I decided to enter the fascinating world of autofocus almost two years ago and began exploring different camera systems. Before long I was carrying around three different systems and lenses, none of which were compatible with each other. I had been shooting with the Canon F-1 systems up until then, and for many years these were the perfect systems for an underwater and nature photographer. I used the old-style Canon F-1 systems in Oceanic aluminum housings for my underwater work. The F-1 had a wonderful Speedfinder prism that could be viewed from as much as two feet away with no loss of the frame area, and it could even be

tilted 90 degrees with a simple rotation to become a waist-level finder. I once was trying to photograph a shy moray eel, which would not come out of its hole when I was too close. With the Speedfinder I was able to hold my camera housing a full arm's length away, and the eel came out.

Nikon's Actionfinder cannot be twisted into a waist-level finder. When you use it with the F4 camera, you lose the camera's matrix metering capability, which is one of the more important features of the system. The Actionfinder for the F4 costs as much as a new 8008s body. The F4 weighs twice as much as the 8008 and costs three times as much. The F4 justifies its greater

weight and price in one very important way—it allows viewing of 100 percent of the picture area. This is no small deal. With the 8008 cameras, you can see only 92 percent of what you are actually photographing, and 8 percent of a picture area is a lot of picture. One photographer has mentioned that a person's head in the average portrait only takes up 10 percent of the picture area.

The old-style Canon F-1 bodies, and most other all-mechanical cameras, are much more robust than any of the electronic bodies made today. I flooded both of my old-style F-1 bodies with sea water, and they both were back in use after a freshwater rinsing and servicing. They

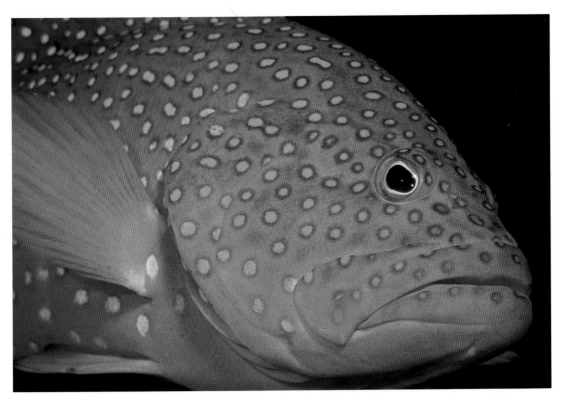

Coral grouper, Red Sea. *Nikon 8008s in Stromm housing, Nikon 100mm macro lens with flat port, Ikelite Ai strobe on TTL, SR2000 slave strobe, Kodachrome 64, 1/60 sec., f/16.*
Fish portraits are best taken with a housed camera and macro lens. If you try to take this kind of shot with a Nikonos, you will endure much frustration and wasted film.

Anemonefish in anemone, Fiji. *Nikonos V, UW-Nikkor 20mm lens, Oceanic 2001 strobe, Fujichrome 100, 1/60 sec., f/5.6.*

I took this shot on top of an undersea pinnacle. When I took this photograph, I carried my housed system along with a Nikonos equipped with a 20mm lens in my pocket. I took several shots of the anemonefish in this scene with my housed camera, which was equipped for close-ups. For a wide scene of this enormous anemone, I simply took out my Nikonos and hooked up my strobe with the underwater pluggable EO connector. With the Nikonos, I was able to show a wide view of this prolific site, and the strobe fill brought out the colors.

still work to this day. My new-style Canon F-1 was destroyed, however, when I accidentally tipped it in the salt water in the bottom of my boat. It was a total loss because of the electronics.

The new Minolta, Pentax, and Canon EOS bodies aren't well suited for underwater systems. Their TTL flash connections are not compatible with Nikon's, but most underwater flashes are made for Nikon because of the TTL-compatible Nikonos V, which has dominated the amphibious camera market. None of Canon's cameras allow removable prisms, so they are hard to focus with underwater, and Canon's macro lenses only focus down to 1:2, a decided disadvantage compared with Nikon's

1:1 capability.

Nikon has decided to keep its thirty-year-old lens mount, so just about any Nikon lens still fits the new autofocus cameras. No matter what the Nikon representatives or salespeople tell you, however, Nikon's autofocus system is not nearly as fast as Canon's. Nikon's autofocus lenses are just clunky. They make a lot of noise, jump around like pythons, and take too much time to override manually. Also, handling the lenses as they autofocus can damage most of them.

Strobes

I carry two *Ikelite Ai strobes* for use on my housing for close-ups and as a backup for wide-

angle shots. The narrow beam angle (80 degrees) of these strobes gives a hotspot when shooting wide-angle photographs. The Ai strobes are compact but poorly made. I use them only because they provide TTL capability and allow the use of Ikelite's wonderful interchangeable strobe cords. The difference between their half- and full-power settings is nowhere near true, and their claimed ability to change between an 80- and 95-degree beam angle is a fable. I do use the modeling light built into the strobe on night dives, and it provides enough light to focus by. In terms of customer service, Ikelite is one of the best manufacturers of underwater gear, and if any of my Ikelite gear needs parts or service, I can depend on parts or repair within two weeks. I have waited as long as six months for other housing manufacturers to deliver promised parts.

The *Ikelite Substrobe 150* is my workhorse strobe for wide-angle shots, along with 20mm and 15mm Nikonos lenses. Although it is large and heavy, I like its modular design, modeling light, TTL and slave capabilities, and soft, wide beam. Most importantly, the strobe offers quarter-, half-, and full-power settings that differ by true stops.

Ikelite makes an entire line of interchangeable strobe cords that plug into Ikelite strobes on one end and offer Nikonos TTL, Nelson, or EO connectors on the other end. With Nelson and EO connectors, you can switch strobes from one camera to another while underwater. Unfortunately, neither of these connectors allows the strobe to be used on TTL, as they do not have the five pins needed for TTL flash communication. I carry two *Ikelite EO connectors* in my case, along with two *Ikelite TTL cords*. The Nikonos TTL strobes and cords, which allow the camera and flash to communicate, have a total of five electrical pins, and the cord must be sealed into the camera or housing on land. TTL strobes and cords cannot be unplugged underwater.

My two *90-degree EO* to Nikonos III-IV-V *adapters* allow my Nikonos V and housed cam-

era systems to become underwater pluggable systems, again with the loss of TTL capability. These are female receptacles for the male EO cords coming from the Ikelite strobes. Unfortunately, the 90-degree EO adapter is no longer made. Helix Photo makes an EO pigtail adapter, which serves the same purpose but is not nearly as robust or compact.

Sea and Sea has announced an upgrade of its popular YS-200 strobe in a TTL model that features a modeling light and interchangeable cords. When these strobes are available, I will probably replace my Ikelite Ai strobes with them. They feature a nice, wide-angle beam (110 degrees) in a unit only slightly larger than the Ai strobe. Their battery units are tiny, rechargeable nicad cells that give as many as 300 flashes per charge. Unfortunately, this also will call for replacing strobe arms and cords, an expensive and time-consuming prospect. Camera Tech in San Francisco can adapt these strobes so that they accept Ikelite cords. With this change, you can switch from Nikonos-type cords to the underwater-connectable EO or Nelson cords. Camera Tech carries the *Isotecna* line of Italian-made strobes, which are compact, light, and TTL compatible. These aluminum-encased strobes look like winners, but I have not had the chance to test them.

I use the EO cords and adapters on all my cameras and housings so that I am able to change cameras underwater and use the same strobe for all cameras. For example, my housing accepts EO cords and I'll shoot macro subjects with it. In my BC pocket I will often carry a Nikonos with a 20mm or 28mm lens to shoot large subjects that might swim by. The Nikonos has an EO adapter plugged into the strobe socket, so I can simply transfer the strobe from my housing to the Nikonos.

I carry two small *SR2000 slave strobes* (made by Sonic Research) everywhere. I've tested a great number of slave strobes, and this is the only model that works well. This tiny unit is incredibly sensitive to light coming from another strobe, but at the same time it is not

affected by bright sunlight. How this was accomplished, I don't know.

To test my flashes and predict their power, I use a *Sekonic L-718 flash meter* on land. This handheld light meter also measures ambient incident light and has proven invaluable in measuring the power of strobes and catching problems before I waste film. I also use it to make sure that my cameras' TTL systems work.

I've spent more time and money figuring out the arm system for my strobes than on anything else. These deceptively simple pieces of gear can very nearly make or break a career. I currently use anodized aluminum *ball-joint arms* made by *Technical Lighting Control* and *Camera Tech*, marvels of durability and lightness. The only problem with these arms is their incompatibility with the traditional Oceanic-type shoes, mounting plates that provide an attachment point for the arms. Fortunately, an adapter is available to mount these arms onto Oceanic shoes. The old Oceanic ball-joint arms worked reasonably well for decades, but the TLC arms, with an effortless clamping system, are much better in their tolerances and ability to hold a load. Photographers who have not already spent hundreds of dollars on Oceanic shoes should just go with the TLC dovetail shoes. The Oceanic shoes had become a standard for arm mounts, however, and most manufacturers built their arms to fit these mounts. Sea and Sea also makes nice ball-joint arms, as well as a one-piece flexible arm that is heavy but works well.

For quick wide-angle shooting with a Nikonos 15mm lens setup, I use a simple one-piece arm made by my machinist out of an aluminum tube. It attaches to an *Underwater Kinetics quick-release platform*, which in turn is attached to an *Ikelite Nikonos tray*. The entire camera/strobe/lens combination feels and handles like one piece and is ideal for shooting quickly. The UK quick-release platform allows me to pop the strobe off quickly in order to control my light if need be.

The Light Meter

With the advent of the Nikonos V camera and its sophisticated electronics, many photographers and the salespeople who advise them believe that using an additional, separate light meter is no longer necessary. When working underwater, however, a separate light meter is essential for reading light quickly and balancing light.

The *Sekonic L164B light meter*, also called the Sekonic Marine Meter II, is the most commonly used underwater light meter. It has a narrow angle of acceptance and is powered by a small battery that lasts for years. An *Oceanic aluminum bracket* can still be found at some stores; this allows the meter to be attached to any number of Nikonos trays. (Camera Tech in San Francisco makes a similar product.) You can attach the camera, as well as a strobe mounted on an appropriate arm, to the same tray. With this system, ambient light levels can be quickly read from the separate light meter and the aperture set for a correctly exposed, visible background.

Diver in coral cave, Roatan, Honduras. *Nikonos V, UW-Nikkor 15mm lens, no strobe, Kodachrome 64, 1/30 sec., f/2.8.*

This photograph is a classic case where the use of a separate light meter is essential to success. If I had had only the light meter in the Nikonos camera, I would have failed utterly in my attempt to capture the scene in this dark cave. With my Sekonic Marine Meter, I was able to meter the light level of the water behind the diver, and thus get a shot that properly exposed the light coming through the cracks in the cave wall. With the Nikonos camera, the meter would have looked at all the dark areas in the picture frame and given me a reading that would have grossly overexposed the photograph.

Pufferfish, Seychelles Islands. *Canon F-1 in Oceanic housing, Canon 50mm macro lens with flat port, Oceanic 2001 strobe at full power, SR2000 slave strobe for fill, Kodachrome 64, 1/60 sec., f/16.*

By using a slave strobe to fill in shadows left by my primary strobe, I was able to show all the details in this portrait of a pufferfish.

Like the meter in the Nikonos camera, the separate light meter reads ambient light as opposed to light from the underwater strobe. In most cases underwater, you are trying to balance ambient light with the light from your flash. The light meter gives, based on shutter speed and film speed, an aperture value that will properly expose the subject the meter is pointed toward. It is your job to move the flash the proper distance from the subject to match that aperture value with your flash. With the Nikonos V's TTL flash, the camera automatically adjusts its flash to properly expose the subject. But for a balanced photograph with a properly exposed background of blue water or coral reef, you must still use an ambient light meter to determine the aperture value.

The use of a separate light meter rather than the one in the Nikonos camera is recommended for several reasons:
• The Nikonos meter is hard to read. When shooting extreme wide-angle shots with the Nikonos, a task for which it is eminently suited, your eye is not on the camera's viewfinder but on the large optical viewfinder of the 20mm or 15mm lens. The Nikonos V's light meter is at the bottom of the other viewfinder and can be extremely difficult to find with your eye, especially when your eye is located a few inches away, behind a mask. A separate light meter with a large readout provides a fast, easy reading of light levels.

• The light meter in the Nikonos can give inaccurate readings. When shooting wide-angle with the Nikonos 15mm lens, the angle of acceptance is so wide that everything from the sun at the top to the dark bottom is included in the photograph. The sun is so bright that it will fool the Nikonos meter into underexposing the photograph—the meter thinks there is more light than is needed for a properly exposed photograph. Simply put, the Nikonos camera sees too much. A separate light meter has a narrower angle of acceptance; it sees only a small portion of the scene before it and enables you to aim at specific points in the scene that you wish to expose properly.

• The separate light meter gives you a better sense of lighting and leads to an intuitive understanding of light levels in the ocean. It also can be switched from Nikonos to housed camera, yielding consistent readings. If you work with separate light meters consistently over many dives, you will soon come to know immediately, without looking at the meter, what the proper exposure for a scene should be. If you leave your Nikonos camera on automatic, however, you will never gain this sense of light, and your photographs will vary from properly exposed to underexposed.

• Using tricks to fool the Nikonos meter into giving bracketed TTL flash exposures is accomplished more easily with a separate light meter. Many photographers use the automatic TTL flash capability in the Nikonos V camera with great success. There are certain situations, however, where the TTL mechanism is fooled into giving improperly exposed photographs. This most commonly occurs when photographing small subjects surrounded by water. With TTL flash, the camera shuts off the flash as soon as it judges that the subject is properly exposed. If the subject does not fill the frame, light from the flash disappears into the background instead of bouncing back to the meter, and the camera is fooled into putting out much more strobe light than necessary, resulting in an overexposed subject.

In order to get a proper exposure in these cases, you can fool the camera's meter by adjusting the ISO setting upward. For instance, for subjects that only fill half the frame, adjusting the film speed for ISO 100 film to 200 would cause the strobe to give off only half as much light. The camera is fooled into thinking that the film is faster than it actually is, and the subject will be properly exposed. What you're doing here is overriding the camera's automatic mechanisms. To do this, a separate light meter is essential for obtaining a consistent ambient light reading.

Batteries

Batteries are probably the least understood, most mistreated items in my case. Underwater photography takes much in the way of batteries. I use rechargeable nicad batteries and especially like *Radio Shack's high-capacity nicad batteries*, which come in AA, C, and D sizes. These high-capacity nicad cells work as well in my strobes as the more expensive battery packs sold by the manufacturers. Two dozen AA nicad batteries run my 8008s and F4s bodies. My nicad charger and a 220V-to-110V transformer for use in foreign countries allow me to recharge all my batteries in nearly any part of the world. I particularly recommend the *Franzus converters* from Sharper Image stores. These voltage converters come with a complete set of adapters to use in any country in the world. The smaller AA batteries must be charged at a much lower current than the large D cells. Follow the manufacturer's recommendations, which often specify maximum current input for the battery. Please note that *only* nicad batteries can be recharged. Alkaline batteries should *never* be charged, as they can explode.

Other Equipment

Several gallon-sized Ziploc freezer plastic bags are essential. I use these for carrying just about anything, but especially for film. Each bag holds about sixty rolls, and on a typical three-

week-long trip I will use from sixty to one hundred rolls of film. Having film easily viewable in these clear plastic bags allows me to quickly bypass airport X-ray machines; most airport security guards take one look and wave them through. I also carry several small Tupperware or Rubbermaid containers holding the small screws, allen wrenches, batteries, and other accessories necessary for maintaining and putting gear together.

Airport X-ray machines and their effect on film is much debated. A few passes through X-rays will not affect film, but photographers traveling constantly, through several airports and checks, will have their film X-rayed several times. I have only had film fogged by X-rays once. The film was fast ISO 400-speed film that I had carried around on several trips to different countries, and had hence been X-rayed probably a dozen times. Because it was high-speed film that I use rarely, this film was kept in my film bag for three or four trips. Had it been film that I use normally, it would have been used up long ago. The solution: Try to use up your film on one trip, and hand-check your fast film, since it is the most susceptible to fogging. Security personnel at most airports will hand-check your film as long as it is visible in the Ziploc bags.

I use several ice chests for storing and carrying my cameras. They weigh and cost very little compared to conventional camera cases, and they are much less susceptible to theft. I usually carry onto planes with me, rather than checking in, a small selection of lenses, film, and camera bodies calculated to get the job done even if my checked baggage is lost. Everything fits into an Igloo Playmate cooler, and I use hard foam with cutouts to fit the interior of the cooler. The cooler inevitably draws hard glances from flight attendants, who ask if I have beer in there, or frozen fish. It is just small enough to squeeze into an overhead bin on nearly every plane I've been on. The average thief is less likely to steal a cooler, usually thought of as a food-storage container, than a

Photographer Charles Lindsay with the ultimate camera case, Indonesia. *Nikon 8008s, Nikon 24mm lens, Fujichrome 50, 1/125 sec., f/11.*

Famed photographer Charles Lindsay demonstrates the use of my super-duper camera case on a boat in Indonesia.

shiny aluminum case that screams, "Cameras inside!" An added benefit of the Playmate cooler is its simple locking switch, which allows the cover to latch over the cooler yet opens quickly and easily. The triangular cover protects the camera gear from rain and splashes. The interior foam that I cut to fit my various lenses protects the gear from the bumps and shocks of traveling in a car or boat.

I use larger, sixty- to one-hundred-quart plastic coolers for checked baggage. I store my tripods, diving gear, underwater housings, some camera gear, and clothes in these. The large Coleman coolers are best for this. They

have better handles, are stiffer, and seem to have more interior space than the Igloos, which have thicker walls. One advantage of using coolers for diving gear and underwater cameras is that after my trip, I can just fill them up with fresh water for rinsing, then drain from the bottom.

Traveling internationally has its own rules and tricks. Make sure you know all the regulations concerning excess baggage before you go. For instance, I arranged to fly to the Red Sea via Egypt Air after a convention in London. Egypt Air is the best way to fly to the Red Sea from the U.S., as it has two nonstop flights from New York and Los Angeles each week direct to Cairo. Flying from the U.S., passengers are allowed the standard two checked bags of seventy pounds, and the fare is only slightly higher than the shorter flight from London. I discovered to my surprise, however, that the allowance for checked baggage is much lower when flying from London, because the rules for airlines that apply in the U.S. don't apply overseas. I was initially charged $700 for my bags, and after much handwringing and begging only managed to get the excess baggage charge down to $350. In cash. One way. For travel for a story that was sponsored in part by Egypt Air. All because I assumed that it would be cheaper and easier to fly to Cairo from London. With international travel, it is cheaper and easier to travel with a partner. On this Cairo flight, I could have flown an assistant in with me for less than I paid for the excess baggage.

I usually wear some sort of windbreaker, especially when shooting from a boat. A Goretex jacket is waterproof, and I can quickly use it to protect my camera from a splash. I recently saved my lens from oily whale breath when a gray whale blew out close to a boat I was on. I also use the windbreaker to cover my long lenses on tripods when photographing in rain

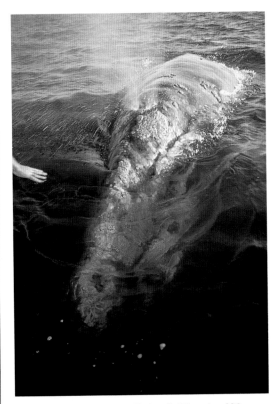

Gray whale exhaling, Baja, California. *Nikon 8008s, Nikon 24mm lens, Kodachrome 200, 1/60 sec., f/5.6.*

Only by quickly covering my camera with my waterproof windbreaker was I able to save it from the oily breath of this whale.

or heavy fog. The windbreaker fits into a small nylon bag and packs easily when not in use.

I haven't gone into some of the more gory details of packing, or deep secrets such as using old socks and underwear to pad lenses. The equipment and techniques of photography are endlessly changing, as is my underwear. Every photographer develops his own style and method of getting the job done.

Examples

Whether you use a Nikonos or a land camera in a housing, one of your most important decisions is determining which lens is the proper one for the subject. Fortunately, this process is relatively simple once you learn the properties and characteristics of each lens underwater. The subject of the photograph will dictate the lens to use. Will the subject be divers swimming through a lush kelp forest, an aggressive six-foot shark, a school of fish, a turtle, or a small fanworm? Each requires a different lens. Your choice of lens can also affect how a subject such as a kelp forest will wind up looking in the photograph. An extremely wide-angle lens will make the kelp forest look very large and spread out, whereas a lens with a narrower angle might make it look lusher and denser. Taking examples from topside photography, shots of Las Vegas neon signs or Los Angeles traffic jams are almost always taken with a long telephoto lens, which compresses objects and makes them look closer together, to achieve a close-packed look. Conversely, many scenic shots are taken with a wide-angle lens to show depth, to make the scene look like a sweeping vista.

The subjects you will encounter underwater determine what camera system you should take. You can't reload film or change lenses underwater, so what you take down is what you are stuck with for that dive. It's very time-consuming to come back to the shore or boat to change cameras, lenses, or film once you have put on all your gear and gone down. By then the dolphin that got you so excited has left, and the wide-angle lens you rushed up to put on your Nikonos in place of the extension-tube kit is useless.

You need to prepare in advance a specific camera and lens combination for each type of subject you expect to encounter during your dive. For fish portraits and close-up work, I use a housed system with 50mm and 100mm macro lenses and two small strobes. For shooting wide scenics, I often use a housed system with a wide-angle lens and two large strobes. For fast-moving subjects such as marine mammals and sharks, I use a Nikonos body with a 15mm lens and one large strobe.

Familiarity with equipment is the single most important thing in getting the picture. And a great part of getting the desired picture lies in recognizing the equipment used to take that picture. At the beginning, the best thing you can do is specialize in one type of photography until you master it. Keep it simple. Know in advance what you want to shoot. Stick with one camera/lens/shutter speed/film speed combination until you've mastered it, then move on to another technique. I started with extension tubes on a Nikonos camera, with a medium-sized manual strobe mounted firmly above the center. I limited myself to close-ups until I mastered them. Now I'm concentrating on photographing sharks, whales, and dolphins; I began by shooting nothing but a Nikonos with a 15mm lens. Lately I've been experimenting with my lighting technique for wide-angle shots and have been using a housed system to shoot wide-angle scenics.

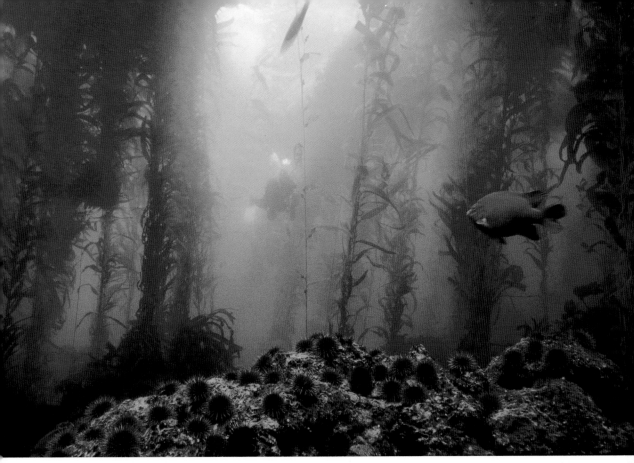

Giant kelp forest, San Clemente Island, California. *Nikonos V, UW-Nikkor 15mm lens, no strobe, Kodachrome 64, 1/60 sec., f/5.6.*

A wide-angle lens such as the Nikonos 15mm gives a sweeping vista of a scene. It has a great depth of field so that subjects from as close as one foot all the way to infinity can be in focus.

Giant kelp forest, Monterey, California. *Nikonos V, UW-Nikkor 28mm lens, no strobe, Ektachrome 64, 1/60 sec., f/5.6.*

A narrower lens underwater can make scenes such as kelp forests and coral reefs look more packed together. Using the narrower 28mm lens in this photograph made the kelp forest look more dense and compressed.

Barracuda school, Sipadan Island, Borneo.
*Nikonos V, UW-Nikkor 15mm lens, Ikelite 150
strobe at half power, Kodachrome 64, 1/60
sec., f/5.6.*

*This photograph shows a wide-angle view
of a school of barracudas. They look spread
apart, not as thick as I remembered them.
This is a property of extremely wide-angle
lenses such as the UW-Nikkor lens.*

Barracuda school, Sipadan Island, Borneo.
*Nikon 8008s in Stromm housing, Nikon 50mm
macro lens with flat port, Ikelite Ai strobe
on TTL, SR2000 slave strobe, Kodachrome 64,
1/60 sec., f/5.6.*

*The same school of barracuda, taken with a
narrow 50mm lens, becomes a closely-packed,
dense grouping. The narrower lens acts as a
mild telephoto in underwater scenes, bringing
subjects closer together, compressing them
in the frame.*

Spotjaw blenny in brain coral, San Blas Island, Panama. *Nikonos IV-A, UW-Nikkor 35mm lens mounted on 1:2 extension tube, Aquaflash on full power mounted 7 inches from subject, Ektachrome 64, 1/90 sec., f/22.*

I shot this sequence of photographs on the first three rolls of film I had ever taken. Because I was diving the same reef day after day, I became familiar with the subjects on that reef and returned to photograph this blenny several times with different tube combinations. I made several other exposures at f/16, f/11, and f/8, but this one at f/22 was the best. This photograph was taken with a 1:2 extension tube, which takes in a scene four times the area of the film frame.

Spotjaw blenny in brain coral, San Blas Island, Panama. *Nikonos IV-A, UW-Nikkor 35mm lens mounted on 1:1 extension tube, Aquaflash on full power mounted 7 inches from subject, Ektachrome 64, 1/90 sec., f/16.*

This photograph of the same blenny in Panama was taken with the same setup as above, except that I used a 1:1 tube rather than a 1:2. The 1:1 tube is twice again as long as the 1:2 tube, and it takes away one stop of light. I set the aperture at f/16 rather than f/22 to compensate. What you don't see here, of course, are the many different shots I took at different apertures. Hedging your bets by making several different exposures of the same subject is the professional's secret called bracketing. A photograph can be bracketed in terms of composition, by moving the subjects to different points within the frame, or exposure, generally accomplished by varying the aperture by full or half stops.

Close-up Photography
Extension Tubes

When I first decided to buy an underwater camera, I started with extension tubes on the recommendation of several books. The equipment for taking Nikonos close-ups underwater is inexpensive. With a set of extension tubes ($150 for a full set, often free with the purchase of a Nikonos body) and a small strobe (which every underwater photographer should have anyway), anyone can take stunning close-ups. This simple setup can give publication-quality photos from your very first few rolls of film, provided that you use it correctly. The equipment and techniques are simple, and the ratio of good to bad exposures is high.

Extension tubes are simple aluminum tubes that extend the lens out so it can focus on a smaller object. The lens is set to its nearest focus, the aperture is set to the highest setting (f/22) to maximize depth of field, and the shutter speed is set to the highest sync speed possible (1/90 second for the Nikonos V, 1/60 second for other Nikonos models). Strobe provides all of the light for the exposure. TTL flash control works well for close-ups. Manual strobes take a little more time to work out, but the basic lighting technique remains the same.

Because the extension tube adds no lens elements, the quality of photographs taken with this system meets the highest professional standards. The main problem is positioning the strobe correctly. Large strobes like the Ikelite 150 can be made to work, but smaller strobes are easier to position. Since strobe speeds are on the order of 1/1000 to 1/10,000 second, in almost all cases the camera will freeze action. I recommend starting with the Nikonos, a 35mm lens mounted on a 1:2 tube, and one strobe only, mounted firmly on a good bracket/arm/tray combination with the strobe about seven inches from the framer (four inches for a 1:1 tube, two inches for a 2:1 tube). The strobe should be mounted on a stiff arm that positions it about four inches directly above the Nikonos camera. The high angle of the strobe will minimize the problem of backscatter.

With the Nikonos V and a TTL strobe, exposure will be automatic and accurate in nearly all cases. With a manual strobe, you will need to keep notes of the aperture values. While keeping the strobe in the exact position each time, vary the lens's aperture for the first few subjects you encounter underwater. For each subject, start by shooting at f/22, then open the aperture to f/16, f/11, and finally f/8. When your film is processed, one of those exposures will be accurate. If you maintain the strobe at the same distance from the subject, that aperture value will be very nearly constant. As magnification is increased, you must move the strobe closer or open up the aperture to compensate for light loss in the longer extension tube. The power of just about all small strobes on the market is nearly the same.

Glass jelly, Arctic Sea. *Nikonos V, UW-Nikkor 35mm lens mounted on 1:2 extension tube, Oceanic 2001 strobe on full manual power, SR2000 slave strobe, Kodachrome 64, 1/90 sec., f/11.*

Creatures that float about in the water column are best photographed with framers. Using a housed camera while diving in bottomless blue water can lead to disorientation and frustration. With a Nikonos camera, however, the framer can be placed right over the jellyfish. Because the bells of jellies can be translucent, the trick in photographing them is to angle the strobes so that light bounces around inside the bell. In this case I used side-lighting, with two strobes set at the sides of my framer. I opened up my lens aperture to f/11, as much light is lost depending on the translucency of the jelly. The colors of the jelly result from light being refracted at different angles. Several photographs on the roll of film were properly exposed but lacked color. Once again, the practice of bracketing exposure and composition resulted in one photograph that stood out above the rest.

Brain coral pattern, Roatan, Honduras. *Nikonos V, UW-Nikkor 35mm lens mounted on 1:2 extension tube, Oceanic 2001 strobe on full power, SR2000 slave strobe, Kodachrome 64, 1/90 sec., f/22.*

The first shot of the spotjaw blenny in brain coral used only one strobe. Because there was only one light source, coming from above, the grooves in the coral cast harsh shadows. The use of two properly positioned strobes reduces the harsh shadow areas that occur when using just one strobe. In this photograph a second SR2000 slave strobe was placed to the side of the main strobe. Both strobes filled the shadows left by the other strobe with their light.

Because the strobe is providing all the light underwater, it is desirable to use a high aperture to maximize depth of field. If the strobe is too weak to give you an aperture value of f/16 or f/22, just bring it closer to the subject. Your subject should be just in front of the framer, as depth of field in close-up photography is very shallow. Because of the framer, don't even bother trying to shoot subjects like free-swimming angelfish, which object to having a framer put around them. Instead, look around for small creatures, color, and patterns. Bottom-dwelling fish that don't swim freely about but instead retreat into holes or into sand can sometimes be enticed into the framer.

Most extension tubes come with framers designed for the UW-Nikkor 35mm lens. The same tubes can be used with the UW-Nikkor 28mm lens, which is optically corrected for underwater use. Because it is optically corrected and because the distance from lens to subject is slightly less, the 28mm lens will give sharper results. The length and size of the framers will be different, however. Helix Photographic in Chicago usually stocks these 28mm framers.

With extension tubes mounted on a Nikonos, you will have problems if a large animal such as a turtle swims by—if you're lucky you'll get a picture of the turtle's eye and possibly a shot of the scales on its shell, but little else. Using a close-up lens solves this problem.

Nikonos Close-up Kit

The Nikonos close-up kit is a diopter that mounts in front of a 28mm or 35mm lens. It uses removable framers that attach to the lens with a long rod. The close-up kit is big, bulky,

and poorly designed. It can cause the lens to pull out of its O-ring seat, creating a flood. I don't really like it but I keep it in my gear bag anyway. Because the lens is an external piece of glass, sharpness is not as good as with extension tubes. There are so many small parts to the kit that vital pieces can easily be lost. The rod, lens holder, and screws that put the unit together are made of dissimilar metals; this creates problems in salt water, as both screw heads tend to seize in the metal and break off. To prevent this, thoroughly rinse and soak the close-up kit immediately after each dive. I also have solved this problem by drilling and tapping enlarged screw threads into the kit and replacing the metal screws with nylon ones.

The close-up kit does have its advantages, however. It can frame larger subjects than can extension tubes. Since it has a framer, it works well for planktonic subjects such as squid and jellyfish, which, when hanging in blue water, are difficult to focus on with a reflex camera. Framers in general are good for capturing fast-moving objects that are hard to focus on. Most importantly, if something big swims by, you can take the close-up diopter off while underwater in order to take a wider view of the subject with the prime 35mm or 28mm lens.

The same lighting techniques as in all close-up work apply. Two strobes, positioned at the top and at one side of the subject, can create a well-lit photograph with no harsh shadows.

For close-ups, the Nikonos camera works well for subjects that don't object to having a framer put around them. For portraits of fish and just about anything else that moves and is between four inches and two feet long, you'll need a housed SLR system. Trying to take fish portraits with a Nikonos camera will only lead to frustration and result in photographs that aren't up to expectations.

Housed Cameras
Housed cameras with 50mm and 100mm macro lenses are ideal for taking photographs of fish. The Nikonos is fine for subjects that are

Kelp bulbs, Catalina Island, California. *Nikonos V, Nikonos close-up kit mounted on UW-Nikkor 28mm lens, Ikelite 150 strobe on TTL mounted 11 inches from subject, Kodachrome 64, 1/90 sec., f/11.*

Kelp plants are notoriously difficult to photograph. They tend to suck up light, so that photographs of them usually turn out too dark. The bulbs are constantly in motion, swaying with the ever-present surge. Using a housed system to focus on these bulbs as they sway about can cause quite a headache. In this case, the Nikonos camera with a framer works wonders. I simply placed the framer over these kelp bulbs and took the picture. The large strobe on TTL put out enough light to make a proper exposure. I intentionally opened up the aperture to f/11, knowing that kelp needs lots of light to be properly exposed.

small and immobile or large and mobile; it is not suited for focusing on and framing small, moving subjects, however, because it is a viewfinder camera, and will have parallax and depth-of-field problems. With the housed SLR system, on the other hand, there is no parallax problem because you view through the lens rather than a separate viewfinder and see exactly what will come out on film, and there is no depth-of-field problem because you focus directly on the subject rather than estimating distances, as must be done with the Nikonos.

Macro lenses come in several different lengths. The longer the lens, the farther away the subject can be to fill the frame. I recommend starting with a 50mm or 60mm macro lens, which is a short focal length. Working with this lens ensures that you'll be in close to the subject and that the strobes used to light the subject will be at a high angle to the lens, important for eliminating backscatter. For years I worked with an old, aluminum Oceanic housing, with a Canon F-1 camera and 50mm lens that could focus down to only 1:2. I used one manual strobe centered over the subject, and this system produced the bulk of the material in my library today. I recently switched over to using Nikon 8008s autofocus cameras in Stromm ABS plastic housings. The autofocus works well underwater, and the TTL flash works well in nearly all cases.

Autofocus cameras generally allow two focusing modes: a continual focus mode, which tracks a subject as it moves, and a single-servo mode which holds its focus as long as the shutter is kept pressed down. I've found that I prefer the single-servo mode in most cases, as it allows me to focus on a subject and then keep focus locked as I reposition the subject in the frame. This method of locking focus is a very important one to keep in mind when faced with a subject that the autofocus sensor cannot lock on to, such as silhouettes or fish without contrast. The continual focus mode is best for situations in which a fish or other subject constantly moves about.

A great advantage of a housed system is its versatility. On one dive, I'm able to photograph subjects as large as a turtle and as small as a fairy basslet. I'm also able to approach timid creatures without disturbing them. The 50mm and 60mm macro lenses are short lenses, which means that you must be very close to the subject in order to fill the frame. A longer lens such as the 100mm macro lens allows you to fill the frame with a subject that may be small and far away. For small, skittish fish in tropical waters, the 100mm will produce better results.

When shooting with a housed manual-focus camera, both of your hands are generally occupied. One hand is on the focus knob, and the other holds the housing steady, controls the aperture, and squeezes off the shutter. Because of this, I generally bracket the strobe exposure by changing the aperture and not by varying strobe distance. My strobes are mounted to the housing with ball-joint arms, which attach quickly to the housing by slipping into a quick-release shoe. With my new autofocus housing, however, I often have one hand free and use this hand to steady my entire body as I follow a subject around a reef. The 8008s camera, equipped with the MF-21 control back, brackets my exposure automatically.

Blue-ribbon eel, Fiji. *Canon F-1 in Oceanic housing, Vivitar 90mm macro lens with flat port, Oceanic 2001 strobe at full power, Kodachrome 64, 1/60 sec., f/11.*

These small eels are notoriously difficult to photograph, as they retreat into their holes at the slightest disturbance. A 100mm macro lens allowed me to stay far enough away from this eel so that it remained out of its hole, and yet still be able to fill the frame with its face. Even with the longer lens, the basic rules of underwater photography still apply. The closer the subject is to the camera, the better the photograph.

Harlequin tuskfish, Heron Island, Australia. *Nikon 8008s in Stromm housing, Nikon 60mm macro lens with flat port, Ikelite Ai strobe on TTL, SR2000 slave strobe, Kodachrome 25, 1/60 sec., f/16.*

In this photograph I wanted to get a shot of the brightly-colored tuskfish that frequented a bommie off Heron Island. I knew that these fish move about quite a bit but stay within the vicinity, so I chose to use the continual focus mode. The Stromm housing allows only one control—shutter release—and I'd had my machinist put in a gear to control aperture underwater. (Other housings allow more control of the camera.) I preset the autofocus mode and shutter speed before going in the water. Because continual focus mode changes focus as the fish moves about, I was forced to keep the fish's eye, the most important part of the frame, near the center of the frame, where the autofocus sensor is located. A giveaway to the limitations of autofocus cameras is this sort of composition, where the subject is located at dead center.

Queen angelfish, Roatan, Honduras. *Canon F-1 in Oceanic housing, Canon 50mm macro lens with flat port, Oceanic 2001 strobe at full power, Kodachrome 64, 1/60 sec., f/16.*

The older, manual focus cameras had a lot going for them. Here, unlike in the shot of the harlequin tuskfish, I was able to control focus manually on this angelfish and judge for myself where to put the subject in the frame.

Squarespot anthias, Sipadan Island, Borneo. *Nikon 8008s in Stromm housing, Nikon 100mm macro lens with flat port, Ikelite Ai strobe on TTL, SR2000 slave strobe, Kodachrome 25, 1/60 sec., f/16.*

This photograph highlights two problematic situations when using autofocus. Because the fish does not have definitive lines crisscrossing its body, the autofocus sensor of my Nikon 8008s camera had a hard time locking focus onto the fish. The fish was also small and quite active, darting about constantly in its nervous balance between food and shelter. Continuous focus mode would not work on this fish since the autofocus could find no lines to lock on to. By using single-servo autofocus, I had a hard time following the fish around. I solved the problem by focusing on my hand, and locking focus by keeping the shutter pressed down halfway. When the fish swam through this zone of focus that I had set, I immediately tripped the shutter. I shot an entire roll of film on this fish, and perhaps six shots were in sharp focus.

Feather star, Solomon Islands. *Canon F-1 in Oceanic housing, Canon 50mm macro lens with flat port, Oceanic 2001 strobe at full power, Kodachrome 64, 1/60 sec., f/11.*

In most cases underwater, the ambient light is so low that the background of a close-up photograph is completely black. Sometimes, however, the light from a strobe may reflect off a background and give a bit of color. A black background is quite dramatic and works well in many cases, but sometimes you may want to achieve a different look. In order to get a blue background in a close-up underwater photo, you have to point the lens at the sun or the water's surface, which will show up as blue. This type of shot is easier to do with a housed SLR camera, as you can see exactly where the lens is pointing and the in-camera meter will give you an aperture reading. I found a crinoid perched on top of a coral head, which made it easy to get below the animal and shoot up toward the sun. The resulting photograph shows the crinoid lit by strobe light against a bright blue background.

Rockfish in aggressive posture, Monterey, California. *Canon F-1 in Oceanic housing, Canon 50mm macro lens with flat port, Oceanic 2001 strobe at full power, Kodachrome 64, 1/60 sec., f/16.*

Most close-up shooting is done through a flat port, which magnifies the image by 25 percent. With macro lenses, the distortion that might otherwise show up when using a flat port is negligible. For lenses wider than 50mm, a dome port is generally needed to prevent distortion. Slight differences in focal length can make a difference in how a photograph turns out. For instance, I liked using my Canon 50mm macro lens behind a flat port. The 50mm lens was a short lens, and I could get right up to subjects like this rockfish. This rockfish's mouth looks a bit wider than it actually is, because it is closer to the lens than the rest of its body. With my new Nikon 60mm macro lens I'm not able to get this slight wide-angle perspective behind a flat port. With a dome port, however, I can get the same effect, as the dome port does not magnify the image and I can get closer to the subject. This is a small point, but it does demonstrate the fact that different lenses give different effects.

Wide-Angle Photography
Nikonos versus Housed Systems

Sooner or later every underwater photographer must decide whether to go with a Nikonos system or shell out the money for a housed system. In most cases, he already has a Nikonos camera, small strobe, and close-up accessories. He has been shooting close-ups and also using the 35mm or 28mm lenses by themselves, which generally yields poor results because of the lenses' narrow angle of view and shallow depth of field and the limitations of the Nikonos camera viewfinder system.

The avid fish photographer has little choice but to use a housed system. Most other underwater photographers, however, would like to shoot a variety of subjects: turtles, sharks, divers, and wide scenic views of coral reefs. The Nikonos camera can do all of this adequately and with great optical quality. A housed system will also do the job, with greater accuracy in terms of framing, but at the cost of greater bulk and more parts to fix on land. With the new low-cost housings and the relatively inexpensive Nikon 8008s camera, the cost difference between a Nikonos V camera with 15mm UW-Nikkor lens (about $2000) is only slightly less than that of a housed system (from $2000 to $3000).

With newer autofocus, electronic cameras, it is possible to get such features as matrix-balanced TTL fill flash as well as spot metering. A housing can give greater versatility as well, since the entire range of topside lenses, from 16mm fisheye to 100mm macro, can be used. With the Nikonos camera, you are restricted to basic point-and-shoot photography or the limited close-up capabilities of the camera. Special types of photography, such as over/under shots (see part 8), can be taken only with housed systems.

Fast Action

The Nikonos camera with a 15mm lens is an ideal fast-action, wide-angle system. As long as the subject is three or more feet away, the viewfinder shows essentially the same picture area as the lens sees, so parallax error is not a problem. If the camera comes closer to the subject, however, there will be parallax error. When the subject is closer than one foot, the viewfinder is almost useless, and the main problem is figuring out exactly where the subject is in the frame.

With the Nikonos camera, I turn my attention to capturing fast-moving animals. I have the camera and lens mounted on a tray that also holds a wide-beam strobe securely in position. The strobe points straight out, in the same direction as the lens. Because the strobe has a 100-degree beam angle, its cone of light intersects the 95-degree angle of view of the 15mm lens for any subject greater than two feet away. For subjects closer than two feet, I take the strobe off and hold it far over the camera, to light the subject from above.

Available-Light Photographs

The Nikonos with 15mm, 20mm, or 28mm lens is ideal for taking shots of large animals or schools of fish in available light. No strobe is used for this kind of shooting. In metering for available light, it is important to keep in mind how the meter works. The meter takes in light reflecting from a subject and gives a reading that will make that subject appear middle-toned. If the meter is pointed at a black rock or white sand, it will give a reading that would make those subjects appear gray. The meter doesn't know what it is seeing, so it only gives you a reference around which you must make your own judgments. Because you want a black rock to appear black and white sand to appear white, it is important to take a meter reading from a point in the scene that you want to appear middle-toned.

I have a Sekonic Marine Meter II mounted to my Nikonos tray, and I refer to it the instant I enter the water. In general, I'd like the water around my subjects to appear blue, not black or overexposed, so I scan the water around me to get a reading. I usually get a reading of f/5.6 or

Garibaldi guarding algae nest, Catalina Island, California. *Nikonos V, UW-Nikkor 28mm lens, Ikelite 150 strobe at full power, Kodachrome 64, 1/60 sec., f/8.*

At their best, photographs of fish with a Nikonos camera show a fish within its habitat. It is virtually impossible to get full-frame close-ups of fish with the Nikonos camera, no matter which lens you use. This is because the Nikonos is a viewfinder camera, and fishes are too small and active to frame well with a viewfinder.

f/8 at 1/60 second using ISO 64 film. By setting my aperture to this metered value, I am able to quickly photograph animals I encounter in midwater.

Silhouettes

Silhouettes can be the most dramatic underwater photographs. They are taken by shooting upward, toward the surface of the water. If the subject blocks the sun, the sun's rays will appear around the subject as shafts of light. To meter this type of photograph, it's important to find an area in the frame that should appear middle-toned in the final photograph. In gen-

eral, that area is the surface of the water to the side of the sun. In tropical waters on a clear sunny day, I usually find the aperture value to be f/8 or f/11 (at 1/60 second with ISO 64 film). Taking the meter reading on the sun itself will give an aperture of f/22 or higher, which would render the rest of the photograph dark or black.

Adding Strobe to Wide-Angle Photographs

As in close-up photography, a strobe positioned far away and at a high angle to the camera will minimize backscatter. With wide-angle shoot-

Garibaldi guarding algae nest, Anacapa Island, California. *Canon F-1 in Oceanic housing, Canon 50mm macro lens with flat port, Oceanic 2001 strobe at full power, Kodachrome 64, 1/60 sec., f/11.*
Full frame shots of fish are best taken with housed systems, which allow you to focus on the fish as you see it. The problems of parallax and shallow depth of field are not a problem with SLR cameras.

ing, however, the camera lens sees a far greater scene than it does in close-ups. Consequently, some photographers recommend using very long arms to position the strobes as much as four feet off the camera. I've always found this unwieldy and use long arms only when I have a great deal of time and am shooting with a housed system. Additionally, because of the magnifying effect of water on the flat glass of the diving mask, it is difficult to aim the strobes with any amount of precision. The subject of a wide-angle photograph appears to be 25 percent closer than it actually is, often causing photographers to misdirect the strobe's beam, lighting up the water directly in front of the subject rather than the subject itself. By doing this, particles in the water in front of the subject are lit up, and the resulting photograph is muddy and dark, with a tremendous amount of backscatter.

The most dramatic underwater photographs show a background of blue water or reef, with schools of fish or other subjects in the foreground lit by strobe fill. Balancing the strobe exposure with the ambient exposure is one of the most important techniques to master in wide-angle shooting. Keep in mind that the ambient light determines the shutter speed and

aperture for the photograph. The strobe exposure itself lasts only 1/4000 second or so, and you can control its effect by varying either the distance of the strobe from the subject, the power setting of the strobe, or the aperture. Shutter speed does not affect strobe exposure.

Housed Cameras

Housed systems give you the advantage of seeing exactly what you shoot, although they are much bulkier than the Nikonos camera, and they require more maintenance and tinkering when setting up. With them you can use the full array of topside lenses; I can use all of my Nikon lenses underwater, ranging from a 16mm full-frame fisheye to an 18mm, a 20mm, and even a 24–50mm zoom lens. The different lenses create different effects. The 16mm fisheye lens distorts straight lines and horizons perceptibly on land, but underwater, where there are few straight lines, distortion usually is not noticeable. Extremely wide-angle lenses allow you to get right up to your subjects, thus improving picture quality.

Sea lions, Los Islotes, Sea of Cortez. *Nikonos V, UW-Nikkor 15mm lens, no strobe, Kodachrome 64, 1/125 sec., f/5.6.*
The Nikonos camera with a wide-angle lens is perfectly suited to photographing fast-moving animals such as these sea lions.

Whale shark, Sea of Cortez, Baja, California. *Nikonos V, UW-Nikkor 15mm lens, no strobe, Koda-chrome 64, 1/60 sec., f/5.6.*

I encountered this whale shark while working on a PBS Nature *film about the Sea of Cortez. The two cameramen in front of this huge fish are accomplished underwater photographers How-ard Hall and Marty Snyderman. This is a typical situation for which the Nikonos camera with wide-angle lens excels. The subject is large, and since it is so far away—twenty or thirty feet—par-allax error is not a problem. Time was of the essence whenever we approached one of these animals, as we had only a few seconds to snorkel out and snap a few frames before it swept past.*

The second I entered the water, I took a meter reading at midwater with my Sekonic Marine Meter to get an aperture value that would render the water blue. If I had metered the shark itself, the meter would have given me a reading that would make the whale shark appear middle-toned. Since the whale shark is dark, the resulting photograph would have shown a light gray shark with lighter-than-normal divers and water. The exposure latitude of film probably would have kept the water from washing out, but the divers would have been overexposed. I also preset my focus on the lens for a zone of focus between three feet and infinity. Because I was able to preset the aperture and the focus, I was able to use all my time in the animal's presence taking photo-graphs rather than fiddling with the controls.

The UW-Nikkor 15mm lens is ideally suited for prefocusing in fast situations like this. As the aperture is moved up or down, the depth of field is indicated by two red lines that move up or down on the distance scale. All you have to do is determine the approximate distance from the subject that you will be, set the aperture, and set the focus so that the subject's distance falls between the red lines. In this case, I knew that the whale shark would be greater than three feet from me, but underwater visibility is less than infinity. Because of this lens's great depth of field, at my aperture reading of f/5.6 I was able to prefocus the lens so that everything between infinity and two feet would be in focus.

Whale shark silhouette, Seychelles Islands. *Nikonos V, UW-Nikkor 20mm lens, no strobe, Kodachrome 64, 1/250 sec., f/5.6.*

This is a typical silhouette, in which the shape gives the photograph its impact. I did not use a strobe for this photo, so the bottom of the animal shows up as black. I took the meter reading off the water at the side of the animal, toward the surface, as I wanted to show the black shadow of the whale shark against a bright blue background. I deliberately swam underneath the shark in order to place the sun directly behind it, knowing that the rays of light coming around it would heighten the photo's impact.

Stingray in Stingray City, Grand Cayman Island. *Nikonos V, UW-Nikkor 15mm lens, Ikelite 150 strobe at half power, Kodachrome 64, 1/60 sec., f/8.*

This photograph was taken using the same technique as the silhouette of the whale shark, except that in this case, strobe was used to fill in the details of the bottom of the stingray's body. Because strobe was used, the shutter speed was limited to the shutter sync speed of 1/90 second or lower. I chose 1/60 second, which gave me a slightly smaller aperture and greater depth of field. There is a great misconception that strobes need to be powerful. In fact, the opposite is true. For wide-angle shooting I consistently use the Ikelite 150 strobe on its lowest power setting. Even this power setting is often too intense, and I will put my hand or tie white cloth over the strobe to cut down on the light.

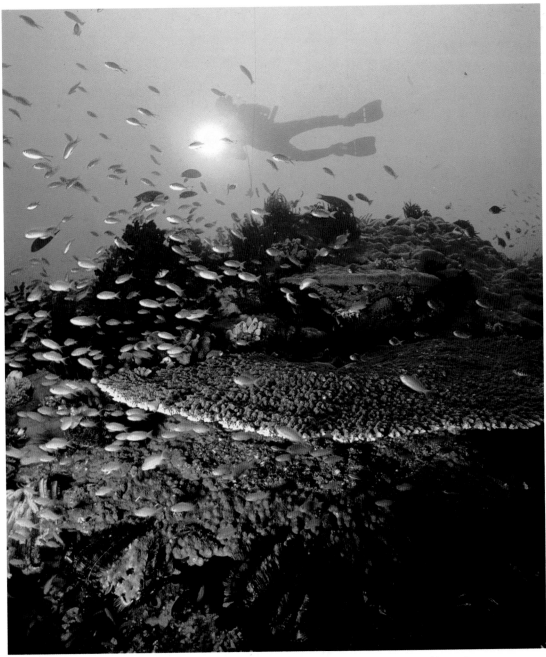

Diver and coral reef, Philippines. *Nikonos V, UW-Nikkor 15mm lens, Ikelite 150 strobe at quarter power, Kodachrome 64, 1/60 sec., f/5.6.*

The diver in this photograph is holding what appears to be a flashlight. It is not a flashlight, however, but an SR2000 slave strobe triggered by the light from my flash. The fish and coral in the foreground were lit by my wide-beam strobe. I determined the aperture by taking a meter reading on the water to the side of the diver.

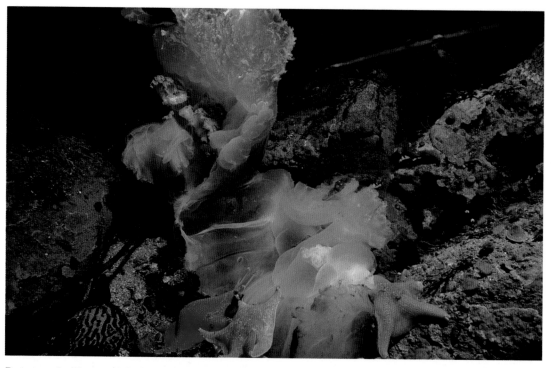

Bat stars feeding on jellyfish, Monterey, California. *Nikonos V, UW-Nikkor 15mm lens, Ikelite 150 strobe at full power, Kodachrome 64, 1/60 sec., f/8.*

When shooting in dark areas like a kelp forest, I often use wide-open apertures and sometimes high-speed film. In these cases, I want just a touch of light from the strobe to illuminate colors in the foreground. The one advantage of TTL-controlled flash is in cutting down the amount of light electronically in such dark situations. For this photo, however, taken in the darkness within a kelp forest, I did not have enough light to make an ambient exposure. Instead, I gave up on having any background exposure and made the photograph completely with strobe light, although having a background that showed the kelp forest would have been preferable. This was taken with my strobe off-camera, held overhead.

Green sea turtles, Sipadan Island, Borneo. *Nikonos V, UW-Nikkor 15mm lens, no strobe, Kodachrome 64, 1/125 sec., f/4.*

A higher shutter speed will freeze the motion of light rays through the water. These coruscating rays, or godbeams as they are sometimes called, serve to heighten the dramatic impact of a photograph, and I try to include them whenever possible. A shutter speed of 1/125 second does a good job, and 1/250 second works even better at showing these rays.

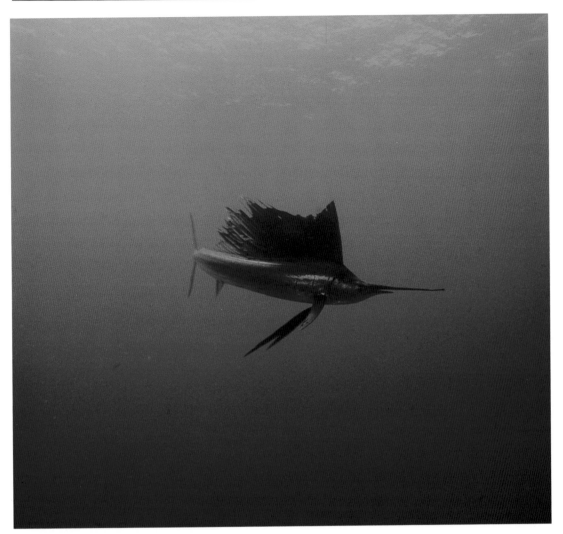

Sailfish, Sea of Cortez, Baja, California. *Nikonos V, UW-Nikkor 15mm lens, Ikelite 150 strobe at quarter power, Kodachrome 64, 1/60 sec., f/5.6.*

This is a perfect example of using flash to fill in shadow detail and of a situation in which the Nikonos excels. With subjects like this rare, fast-moving sailfish, I don't have much time to react, much less to waste focusing and framing the subject. With a Nikonos camera I can preset focus and aperture, then just point and shoot.

I seldom use TTL-controlled flash when shooting wide. Because I often use the strobe to fill in colors or shadows, using flash on TTL control too often results in overexposed foregrounds. In this case, TTL flash would have ruined the picture. The strobe would have put out its full intensity of light, with the camera waiting and waiting for enough light to bounce back from the subject. Light from the strobe, rather than coming back from the subject, would have disappeared into the open ocean, never to return. In the meantime the sailfish's face would have been grossly overexposed. With manual control of the flash, I was able to add a touch of light, just enough to bring out the features of this magnificent fish's face.

67

Damselfish over coral head, Sipadan Island, Borneo. *Nikon 8008s in Stromm housing, 24mm lens with + 2 diopter, Ikelite Ai strobe on TTL, Fujichrome 100, 1/60 sec., f/5.6.*

A 24mm lens in a housing gives approximately the same angle of view as the Nikonos 20mm lens, with the advantage that you can focus closer with a 24mm lens and + 2 diopter. With this setup I can photograph any subject from the very front of my dome out to about five feet. With a + 1 diopter, which is a lower-strength close-up lens, I am able to focus from about six inches in front of the dome to infinity. Using the 8008s body provided TTL fill flash, although without matrix metering (the Ikelite strobes only give center-weighted TTL flash). To get matrix metering under-water with the 8008s camera, you must use the Nikon SB-24 or SB-25 strobes encased in housings made by Tussey, Subal, or Aqua Vision Systems. Doing so gives matrix-balanced TTL flash, the most advanced of flash systems available today, and it will allow you to operate the camera with-out thinking about guide numbers and distance from the subject. I used the manual exposure mode, however, which let me control the aperture and shutter speed.

Manta ray and diver, Sangalakki Island, Borneo. *Nikon F4 in Aquatica housing, Nikon 16mm fisheye lens, no strobe, Kodachrome 64, 1/60 sec., f/5.6.*

This photograph shows the ultra-wide angle of view of the fisheye lens. The manta ray and diver are silhouetted against a circle of light that is the surface of the water. It is impossible to show this entire circle of light with lenses that are narrower.

Urchin barrens, San Diego, California. *Canon F-1 in Oceanic housing, Canon 15mm full-frame fisheye lens with dome port, Oceanic 2001 strobe at full power, Kodachrome 64, 1/60 sec., f/5.6.*

This shot was the result of my first attempt at using a wide-angle lens in a housed camera. I had no idea that domes needed to match nodal points, and I doubt that this setup came anywhere near being optically correct. I gallantly shot off a roll of film, although the image never seemed quite sharp no matter how I focused. The resulting images are typical of a mismatched lens and dome. They are not quite sharp, and the colors are a bit muddy. Besides the problem of matching lens and dome, focusing a lens for a wide-angle scene underwater is difficult. It is very hard to focus on a particular subject within the frame, as the lens is taking in a very wide view and the image in the viewfinder is so small. Small details such as fish just can't be seen well enough to focus on. Also, the curved horizon in this photograph is typical of the distortion of a fisheye lens.

Fairy basslets and soft corals, Red Sea. *Nikon F4 in Aquatica housing, Nikon 20mm lens, two Ikelite Ai strobes on half power, Kodachrome 64, 1/60 sec., f/5.6.*

This photograph could as easily have been taken with a Nikonos and a 15mm lens setup. I used the strobes on manual power so that the small fish coming out of this Red Sea reef would not be overexposed.

Medium-Wide-Angle Lenses

Medium-wide-angle lenses, such as the 24mm and 28mm, actually act as mild telephotos, compressing underwater scenics and squeezing fish together to create a crowded look. Because of refraction, the angle of view of a 24mm lens in a housing is equivalent to the UW-Nikkor 20mm lens used on a Nikonos, and the Nikonos 28mm lens actually has the same angle of view as a 35mm lens above water.

The UW-Nikkor 35mm Nikonos lens is sold as a standard lens for the Nikonos body. It has the ability of shooting scenes both above and below water, which can be useful. But compromises were made in order for it to do both topside and underwater shooting. For one thing, it has a flat port and is not optically corrected for underwater use. (All other Nikonos lenses are optically corrected except for the 80mm lens, which is suited only for topside photography.) The 35mm lens is very difficult to use by itself. It has a narrow angle of view of 50 degrees. Its closest focusing distance is two and a half feet, and the depth of field at that distance is minimal. This narrow angle of view coupled with the shallow depth of field causes great problems when trying to photograph subjects with a viewfinder camera. No matter how experienced or knowledgeable you are, you will still have problems with focus and framing when using this lens. Additionally, few subjects underwater are suited for the 35mm lens. At two and a half feet away, the lens sees a frame about two to three feet in length. There are just so many animals down there that fit this particular frame size. Most reef fish are quite a bit smaller than this, and the few subjects that would fit in this frame, such as turtles, large fish, and divers' heads, are limited in appeal.

The UW-Nikkor 28mm lens is a better underwater lens than the 35mm. The 28mm lens is optically designed for use underwater, and if you use it topside you will get blurred photographs. It focuses down to two feet and has better depth of field (remember that wider lenses improve depth of field). It is useful for

bringing subjects close and for compacting scenes, while a wider lens such as the 15mm would do the opposite.

Anchovy school, Monterey, California.
Nikonos V, UW-Nikkor 28mm lens, no strobe, Ektachrome 64, 1/125 sec., f/11.

This teeming school of anchovies hung about in the shallows of Monterey Bay for a week, during which time I was able to snorkel with them. The 28mm lens made the fish school look as dense and crowded as it did to my eye. Using a Nikonos 15mm lens would have been a mistake, as the lens would have taken in a wider scene, the school would have looked less imposing and more spread apart, and the fish would have been small dots in the photograph, unrecognizable.

Mahi-mahi, Northern Pacific Gyre. *Nikonos V, UW-Nikkor 28mm lens, no strobe, Ektachrome 64, 1/125 sec., f/5.6.*

I had spent days diving in the middle of the Pacific Ocean, hoping to photograph fish that were attracted to a floating buoy our research vessel monitored by radio transmitter. I had seen a few fish the day before, but none came closer than about twenty feet. Knowing this, I prepared my Nikonos with 28mm lens and preset the focus so that the zone of focus encompassed ten feet to infinity. Just as I had predicted, this mahi-mahi stayed its distance, and I was forced to photograph it from about twenty to thirty feet away. A strobe would have been useless in this case, so I ended up with a monochromatic image. The 28mm lens allowed me to pull the subject in to fill the frame even at that distance.

Angel shark in coral reef, Sea of Cortez, Baja, California. *Nikonos V, UW-Nikkor 28mm lens, no strobe, Ektachrome 64, 1/60 sec., f/5.6.*

This photograph was one of my first efforts shooting wide-angle with the Nikonos. The coral reef itself was not much of a reef. Only the use of the 28mm lens (it was all I could afford!) caused this photograph to look special. The 28mm lens acted like a mild telephoto here, compressing the scene so that the coral reef looked denser than it actually was. By focusing on a subject that was far away, I was able to bring both the angel shark and the far part of the reef into focus. The farther away the lens is focused, the greater the depth of field around the subject. When shooting with the Nikonos 28mm lens, I use the viewfinder built into the Nikonos camera, ignoring the lines intended for use with a 35mm lens and instead using the full viewfinder to frame the subject. By doing this, I minimize the parallax error that would result from using an accessory sportfinder, which is situated on top of the camera, farther from the lens than the built-in viewfinder. I've also found that the camera's full viewfinder is a fine approximation of the 28mm lens's angle of view.

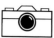

Composition

Teaching composition is the hardest part of photography. Every person has his own way of looking at things, and it is often hard to explain why one photograph of a damselfish is so much more exciting than another. Isolating a subject from a jumbled background and placing that subject in a well-designed photograph requires command of technique as well as an aesthetic sensibility. A photographer must narrow his vision and pick the best subject for the situation. The best photographs convey a mood, tell a story, or show the patterns and abundance of color underwater. While there are no hard and fast rules for composing a photograph, a few concepts and considerations should be kept in mind.

Fill the frame with your subject. Keep the photograph simple. I adhere to the "keep it simple" philosophy in both my photography and my gear. In marine wildlife portraits, make sure that the subject faces the camera and that the eyes are in sharp focus. For more impact, try to get below your subject and shoot up.

Photographing Divers

Divers can be among the most difficult subjects to photograph underwater. Many is the time my photographs have been ruined by divers going through the frame, flailing away wildly, stirring up sediment, with a trillion hoses flapping in the current. The very best photographs of people underwater use a diver for scale only. I am admittedly biased, but my reason for being underwater isn't to photograph the latest colors and styles of wetsuits.

Working with a model underwater can be frustrating. It's impossible to give instructions except by waving a hand, and hand signals are often misinterpreted. The best underwater models keep their gear simple and swim naturally through the frame, rather than stopping in the middle of the picture and attempting to hold position. They also avoid looking directly into the camera and direct their gaze on another subject in the photograph. The best photographers use their strobes to subtly light up the foreground and eyes of the models and use wide-angle lenses to lend impact to the scene. The inclusion of a diver in a scene can give the photograph more action and tension, but the diver must *be* active to look active.

Elements of Design

Negative space is the area of the photograph that is not part of the subject. Negative space can be as important as the subject itself. More often than not, it is the negative space that attracts a viewer to a scene rather than the subject of the photograph itself. Photographs where the subject is surrounded by pure black

Diver, sea fan, and fairy basslets, Red Sea. *Nikonos V, UW-Nikkor 15mm lens, Ikelite 150 strobe at quarter power, Kodachrome 64, 1/60 sec., f/5.6.*

Using a model behind the subject can lend scale to a photograph, making the subject look much bigger due to the wide-angle perspective of the lens.

negative space are common in close-up shots, and black backgrounds are always dramatic. But being able to place a subject in the middle of a scene of bright colors also makes for a visually stunning photograph. When I am

Shark and photographer Bob Cranston in shark suit, open ocean off San Diego, California. *Nikonos V, UW-Nikkor 15mm lens, no strobe, Kodachrome 64, 1/60 sec., f/5.6.*

I was hired to make this photograph for a medical advertisement. To make the main subject seem imposing, an upward angle is best. I was slightly below this blue shark, looking up, as it entered the frame. Because the shark's face fills the frame, and also because the shark is looking down into the camera, I was able to fill the requirement for a diver in a dangerous situation. If I had been shooting down on the shark, it wouldn't have looked as ominous. If the face had not filled the frame, or if the face hadn't been coming toward the camera, the photograph would have lost its impact.

underwater, I'm always on the lookout for brightly colored backgrounds against which I can place a subject. I look for both color and contrast separation, in which different colors or backgrounds make for an interesting photograph.

Diagonal lines leading through a photograph create a sense of tension. Other elements of design include S curves, in which a line winds through the frame, leading the viewer's eye.

The rule of thirds gives positions at which to place your subjects within the photographic frame to create a more dynamic composition. To use the rule of thirds, divide the frame into thirds both horizontally and vertically, with two lines crossing the frame each way. These lines intersect at four different points, each of which is a strong position at which to place the subject. Placing the horizon along one of the lines can create a powerful photograph. Many SLR cameras have optional viewfinder screens that are gridded to divide them into thirds. These gridded screens can be much more helpful for composing than the standard screens, and I add them to all my cameras, as the lines help me both to compose pictures and to keep horizons straight.

Composing for Publication

All of the above elements of composition can produce stunning photographs. No matter how rare the subject or negative space, however, the photograph will not be published unless it fits the format of the publication for which it is intended. Photographers must shoot both verticals and horizontals. Vertical photographs are almost always used for covers, and horizontal photographs fit wall calendars and double-page spreads. Shooting both formats when encountering a worthy subject will ensure that the right format is available the next time a photo request comes in. Also, leave plenty of negative space for art directors to drop in titles and text, and your photograph will more likely be chosen for a cover or double-page spread than other, more crowded photographs.

Damselfish in sea fan, Fiji. *Canon F-1 in Oceanic housing, Canon 50mm macro lens with flat port, Oceanic 2001 strobe at full power, Kodachrome 64, 1/60 sec., f/11.*

This fairly drab damselfish is not that interesting in and of itself. Placed within the bright pink colors of a sea fan, however, the fish becomes vital to this photograph. A photograph of the sea fan or the damselfish alone would not have worked nearly as well.

Anemone foot with radiating muscles, Monterey, California. *Canon F-1 in Oceanic housing, Canon 50mm macro lens with flat port, Oceanic 2001 strobe at full power, Kodachrome 64, 1/60 sec., f/11.*

This close-up detail of the muscle striations on an anemone's foot gains its power through color contrast and diagonal lines. The center of the lines, the anemone's mouth, is placed in the upper-third corner of the frame, and lines of color radiate diagonally down to the lower part of the frame.

Diver with sea lion, Coronados Islands, Mexico. *Nikonos V, UW-Nikkor 15mm lens, no strobe, Kodachrome 64, 1/60 sec., f/8.*

Nearly every element of composition and technique was used in this photograph. The sea lion is diving down out of a sunburst located in the upper left corner. The direction of movement in the photograph is down toward the right corner, and the sea lion's nose and the diver's hand form a single diagonal line. The diver himself, Mark Conlin, is in a position dictated by the rule of thirds. The light from my one strobe just fills in the red color in his drysuit.

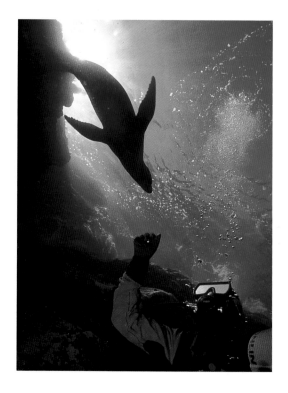

In case you're wondering, no, I wasn't thinking about all these things when I took the photograph. I did shoot almost an entire roll of the sea lion interacting with Mark, and this shot turned out to be one of the most dramatic. Film is cheap; if you encounter a good subject, shoot in as many different ways as possible. One of those shots will stand out from the others.

Cruise ship in sunset, Grand Cayman Island. *Canon F-1, Canon 70—210mm zoom lens, Fujichrome 100, 1/250 sec., f/5.6.*

This is not an underwater photograph, but it was taken on one of my trips to Grand Cayman, and it has become a best-selling image at my stock agency. I've included it here to illustrate the principles of shooting for publication. Because this photograph is a horizontal, it lends itself to a double-page spread. The subject is once again in a dramatic point in the photograph, in a lower corner. The rest of the photograph is pure negative space. Art directors love using this type of photograph in big ads that run across two pages. They can easily fit type into the negative space, and the subject is generic enough that it can advertise almost anything tropical—cruise ships, vacations, islands, and so on.

Juvenile octopus on elephantfish egg case, South Island, New Zealand. *Nikonos IV-A, UW-Nikkor 35mm lens mounted on 1:2 extension tube, Oceanic 2001 strobe on full manual power mounted 7 inches from subject, Kodachrome 64, 1/90 sec., f/22.*

This tiny juvenile octopus made its temporary home under an egg case of an elephantfish, a bizarre deep-sea fish that spawns in New Zealand coastal waters. I made several exposures of this octopus, both with and without the egg case, and this composition was the best. Once again the subject is in a position of power within the frame, in the lower corner, and plenty of negative space at the top made this a natural cover. The Cousteau Society used this photograph for the cover of their Dolphin Log, *with a title dropped into the upper part of the frame.* Photographs and artwork © 1987 The Cousteau Society.

80

Juvenile crab in pelagic jellyfish, Monterey, California. *Canon F-1 in Oceanic housing, Canon 50mm macro lens with flat port, Oceanic 2001 strobe at full power, Kodachrome 64, 1/60 sec., f/11.*

The winding S-curve is a strong yet subtle element in many of the most accomplished photographers' work. Once again, the main subject of the photograph has been placed at a powerful spot within the frame, in the lower right-hand corner rather than smack dab in the center. The curve is formed by the bell of this jelly and winds down to where the crab is sitting, in the interior of what looks like a strange sand dune.

Juvenile crab in pelagic jellyfish. *This photograph was used to illustrate the wrap-around cover of the University of California, San Diego Extension course catalog. The designer flipped the image over so the crab could be on the cover. This composition, with plenty of negative space, lent itself well to having type printed over the photograph.* Artwork © 1991 UCSD Extension (University of California, San Diego).

Organizing and Selling Photographs

The Business of Photography

Most nature photographers have to overcome the expectations of their peers, parents, and colleagues in order to pursue their goal of photography. Most people advised me to continue my career in engineering while working on photography in my spare time. I disagreed; I could not possibly divide my time between the restrictions of a corporate job and a moonlighting job on the side. To produce top-quality wildlife essays or stock photographs, you have to dedicate yourself to shooting a project or studying the market for stock photographs.

To make it in this tremendously competitive marketplace, it is first necessary to believe in yourself and your work and that it is possible to make a decent living doing what you truly love. The good news is that your photographs have as much chance of being published as anyone else's. Where many aspiring photographers fail is in grasping the fact that photography as a business means a continuous, unending stream of office work. This necessarily precludes another full- or even part-time job. Selling photographs is a time-consuming, mind-numbing, and tedious task at best. Over the years I've developed a set of routines in running my business. I've examined the office habits of other photographers and agencies as well. I'll try to explain here how I organize my work, find and keep track of my clients, and use my computer.

Computers

A computer with a good word-processing program, a database, and a mail-merge function that allows custom form letters is a necessity for any business. My mailing list is one of the most important parts of my business, and I update and refer to it every day. I get addresses of potential clients everywhere. Each time I go to a bookstore, camera shop, or card store, I get the addresses of the publishers of the greeting cards, magazines, books, and calendars on the shelves. Lists of newspapers, magazines, and paper products companies abound in libraries. All of these addresses go into a client file in my computer.

I visit clients only rarely; instead, I periodically send all the clients on my list an update of new photographic subjects and story possibilities. Every bit of information, every idea, every phone number, every name and title I hear or

Divers on reef wall, Grand Cayman Island. *Nikonos V, UW-Nikkor 15mm lens, Ikelite 150 strobe at half power, Kodachrome 64, 1/60 sec., f/5.6.*

This photograph is constantly chosen for covers of magazines to illustrate diving. It shows a pair of divers, rather than a diver swimming alone, which art directors don't always like to show because of safety considerations. Working with a stock agency and taking their suggestions will help you to think about small details such as this, which may be the reason your photograph is chosen over a similar one.

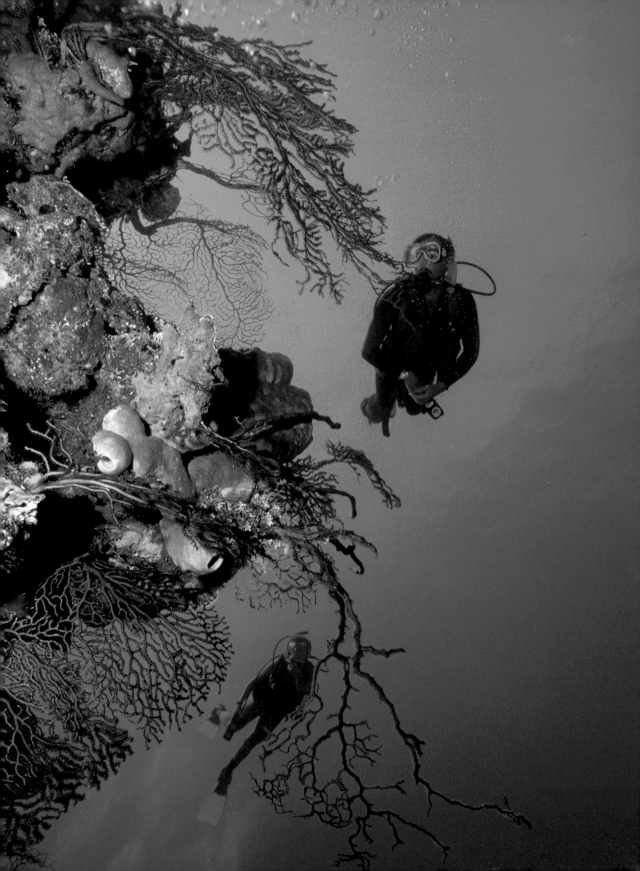

read about goes into my database. This way I know exactly who I am speaking to on the phone and I have a record of our conversations. No information is lost, and I follow up on every lead as if it were my first contact. I subscribe to a dozen or so journals and magazines about the photographic, writing, and diving industries. In the course of my reading, each bit of potentially useful information goes into my database, under the headings of manufacturers of photo-

Limpet escaping from starfish, Monterey, California. *Canon F-1 in Oceanic housing, Canon 50mm macro lens with flat port, Oceanic 2001 strobe at full power, Kodachrome 64, 1/60 sec., f/16.*

Complete essays of natural history subjects, including photographs and text, stand a much better chance of being published than a mere collection of pretty pictures. Behavioral sequences of animals engaged in feeding, reproduction, or defense also do much better than artistic still lifes. In this sequence, a limpet, a type of snail, escapes the attack of a sea star. Sea stars are voracious predators, feeding upon almost anything that can't move fast enough to escape their grasping tube feet and eviscerated stomach. When encountered by a sea star arm, this particular limpet, Diodora aspera, exudes a slippery white mantle that starfish can't hold on to, then speeds away (well, crawls away pretty fast for a limpet) to safety. This behavioral sequence turned out to be my first publication credit in National Geographic *magazine.*

graphic equipment, manufacturers of diving equipment, magazines, adults' books, children's books, museums, advertising agencies, and so on.

I use an Apple Macintosh computer system with a word processor and database, but any computer system will do. I prefer the Macintosh system because it mimics the way most people are used to working: The computer organizes data into files, those files can be organized into folders, and the system works from a "desktop." The Macintosh environment also lets me transfer information quickly between my word-processing program and my database, so I can easily and quickly compose letters to a client, using the address in my database. I use Microsoft Word, which allows me to print customized form letters to different classes of clients. A nice feature of Word is its column-processing capabilities, which allow me to sort according to zip codes, company names, addresses, or any column of information. I also use Word's mail-merge capabilities to print captions for my slides on $3^1/_2$-by-$^7/_{16}$-inch press-apply labels. It may not be the most elegant system, but it works for me. Any decent computer system will do the job, and that's what's important.

Several software packages have been written specifically for the photographer for both the Macintosh and IBM-based computers, and they vary in terms of capabilities. I found out the hard way that these programs can take a great deal of time to learn. After several disastrous and prohibitively time-consuming attempts to apply a few specialized programs to my office duties, I decided to spend my time and money on only the most general, flexible computer programs. On my Apple Macintosh, I've been able to do almost all of my work with the word processing and database programs. I have a spreadsheet package as well, but I have not had the time in five years to learn the capabilities of this program.

My laser printer is another essential investment. It produces professional-looking manuscripts and letters, and it is the only practical way to produce the mass mailings to my clients. My fax machine has also proven invaluable, particularly for reaching international clients.

A personal copy machine is another necessity. By placing a sheet of transparencies on the copier face down and shining a two-hundred-watt bulb over the sheet, it is possible to make a copy of the images I am sending out. The bulb shines light through the transparencies, creating an image on the copy paper. This enables me to keep a record of exactly what photographs have been sent to a client, what caption information was on the slide, and whether the slide was an original or a duplicate (all my originals are stamped as such). Ironically, I can do this only with the smaller, cheaper personal copy machines, as the faster, high-end machines move too quickly to register the light from the bulb.

My final and most important piece of equipment is a good slide-duplicating machine, along with a quality 1:1 enlarging lens. Unless I have a good working relationship with a client, I routinely duplicate any submission and send out dupes rather than originals. I've been able to hold the line on costs by duping submissions myself. For the highest quality, I use the special low-contrast duplicating films (Ektachrome 5071 and Fujichrome CDU duplicating films). These films need to be tested for color and exposure balance with each batch, so I buy in bulk and store them in the freezer until they are needed. I recommend the Beseler or Bowens slide duplicators along with the Rodenstock (Beseler) 75mm f/4 enlarging lens for duplicating. The process of slide duplicating is shrouded in mystery, and it's possible to spend a great deal of money and time searching for that perfect dupe. I have found that the above equipment gives good results with a minimum of fuss. The manual that comes with the slide duplicator gives a good explanation of how to use slide-duplicating films.

Organizing Your Library

I've found that many successful photographers

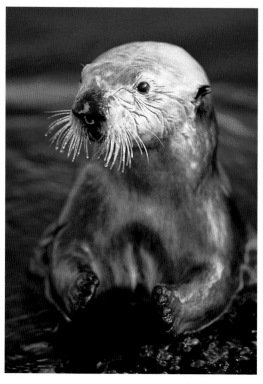

Sea otter, Monterey, California. *Canon F-1, Canon 70—210mm zoom lens, Fujichrome 100, 1/250 sec., f/5.6.*

The director of a bookstore once met with me and went through the work I had prepared for him. His comments were invaluable. Although cute animals such as this sea otter sell well, there are good sea otter photos and not-so-good ones. In the good ones the otters have dry faces with fur that is white and fluffy, rather than wet and dark. The ideal shot would be of a mother and pup both with dry, white faces. The photograph that will be chosen for publication as a poster or card is the ultimate sea otter picture, the very epitome of cuteness. A drowned rat is not cute. A sprightly, fluffy, bright-eyed otter is cute. *The same thinking applies in photographs of people. The very best stock photographs pay attention to the slightest details in a person's clothing, makeup, and posture.*

and agents have not computerized their photo files, and neither have I. I use the computer to handle tasks such as invoicing, letters, mailings, and captioning, but not to keep track of photographs. Instead, I make a Xerox copy of each submission, which gives me a visual record of exactly what each client has. I have a manila folder for each client, and if the client is holding photos, then his folder is put in the "slides out" filing drawer and the number of photos sent is logged on that folder. My client folders are otherwise filed under the same categories as in my computer database.

My photographs, instead of being computerized, are simply organized by location, broken down into categories such as fish, invertebrates, divers, and scenics. Each location has its own filing cabinet. Within each location, the subject categories are organized into separate Pendaflex hanging file folders. Inside the file folders, the photographs are stored in polyethylene vis sheets in manila folders. Dupes go in one manila folder; the very best images, which never leave the office, go into another; and all other originals go into a third. With this system I can quickly scan pages of slides, twenty per sheet, until I find the one I want. This is the only system I've ever seen in use at any agency, and I cannot recommend anything more highly. One book I read when first getting started recommended storing slides in boxes and using a projector with a stack loader to go through your slides. Throw that book away. File your slides in vis files, twenty slides per page, and file by location. Forget those slide filing cabinets as well.

If this sounds like a lot of boring, tedious work, you are right! If there is any secret to my success, however, it has been in proper organization of my office, duplication of submissions, and using the computer practically. By organizing my office efficiently, I am able to find photographs and make submissions quickly. By duplicating my submissions, my best shots are available for other projects and I don't need to

Hermit crab in hydrocoral, Monterey, California. *Nikonos IV-A, UW-Nikkor 35mm lens mounted on 1:2 extension tube, Aquaflash on full power mounted 7 inches from subject, Ektachrome 64, 1/90 sec., f/22.*

This photograph was in the first six rolls of film I ever shot. Several elements of this photo have made it a continual seller; it has been published as a postcard, in several calendars, and in magazine articles. The colors of the shell and the full bleed of color off the frame help make this such a popular image. Art directors love strong, warm colors such as purple and red. Color sells.

worry about valuable originals being lost or held for too long. By using my computer practically, I spend less time learning nuances of a computer program and more time getting work done efficiently. Time is your most valuable asset, and it's my hope that these suggestions will help you save a great deal of this asset in the beginning of your career.

Selling Photographs

I have spent the past ten years building up a library of images from which I can draw on for my articles, books, and clients, which range from natural history museums to advertising agencies. In underwater photography, assignments are few and far between, so just about all of my income results from sales made from my existing library of images. In the course of carving out a niche in this specialized marketplace, I've learned a great deal about the market for photographs in general, and the principles I present here apply to all photographers who plan to sell their existing work themselves or through an agency.

87

Blue shark and the notorious *Betsy M,* open ocean off San Diego, California. *Nikonos V,*
UW-Nikkor 15mm lens, no strobe, Kodachrome 64, 1/60 sec., f/11.
 Photographs of animals dwarfed by man-made structures, such as this shot of a blue shark next
to the infamous Betsy M *off San Diego, are successful in the market.*

There are three basic steps to marketing images. First, you must take the time to develop a library of images, large and extensive enough that most queries from editors and art directors can be filled. This library will take time to build, and it can consist of images from past assignments as well as photographs shot specifically for your library. The second step involves making contact with the agency, publication, or client that can use your image. The third step is record keeping, agreeing on a fair price for the photographs, sending out an appropriate submission, and invoicing. Whether you sell your work yourself, through a stock agency, or both, these procedures and techniques will apply. The key to all these steps is professionalism. Professionalism means that you will first take the time to build up a library of technically excellent images. Only after building up this library will you offer your work to potential clients. Professionalism means that you are informed of your potential clients' businesses and possible uses for your photographs. Professionalism means that you are informed about the going prices for your work and that you can agree with a client on a price quickly and reasonably.

The Stock Library

A stock photograph is simply a photograph that already exists, as opposed to a photograph created for a client for a specific assignment. The development of stock photography in the last decade has been a driving force in the businesses of photographers and their clients everywhere. Photographers did not always have it so good, however. It was the 1976 Copyright Act that granted ownership and copyright of a work to the creator of such work. In simpler language, this means that you own the copyright to a photograph the minute you click the shutter and expose the film. As owner of the copyright, you have the right to license the photograph for specific uses. Only by signing away your right of ownership to such photographs, whether by signing a work-for-hire agreement or by selling all rights to an existing image, do you lose the ability to sell a photograph over and over. The issues of copyright protection are complex, and the references listed at the end of this book can give more detailed explanations of this matter. I will limit this discussion to my average, day-to-day business practices and experiences. The odd contract or arrangement only makes up 10 percent of my work; in general, just about all of my photography sales fall into a standard, one-time, North American usage agreement.

Needless to say, photographs in your stock library must be of high technical quality. Transparencies, 35mm or larger format, are the only practical and accepted medium. Transparencies are used directly to make color separations in the printing process, and the bookkeeping involved in filing and keeping track of a photograph is simplified by using transparencies rather than color or black-and-white negatives. Kodachrome 25 and 64 films and Fujichrome Velvia, 50, and 100 films are the preferred films of my clients, printers, and stock agencies. Subjects must be razor sharp under the inspection of a 8X loupe. A good loupe and light table are the most important tools of the trade apart from the camera and lenses themselves. Use your loupe and edit ruthlessly, throwing away any image that lacks proper exposure, focus, or sharpness.

Aside from the technical quality of the slides, in shooting photographs for stock, be especially aware of composition, negative space, and color. Try to look at a photograph from an art director's point of view. Use the rule of thirds and diagonal lines in your composition to lend power to your photograph. Make use of negative space to isolate your subject and to allow room for copy and titles. Above all, make use of color—color that bleeds off the frame, color that is warm, and color that is separated from the rest of the background.

After building up a library that can satisfy most clients' requests, it's time to let these potential clients know that you're out there. I built

up a mailing list by going to bookstores and libraries and copying down the addresses of every calendar company, card company, and magazine and book publisher that might have a use for my type of photography. I also subscribe to two dozen different journals and newsletters and am a member of the American Society of Media Photographers (ASMP), a professional photographer's society that puts out useful publications on the business of photography and serves as an advocate for photographers' rights. Each new prospect gets a customized form letter describing my interest in contributing or working for the publication, along with a résumé and stock list detailing my photographic files. If the prospect is a magazine, I'll include a proposal for a story tailored to fit the needs of that magazine. If I ever get a call from one of these clients, I immediately send out a complete package including copies of my articles, tearsheets of previous work, and a slide page of twenty 35mm duplicate slides featuring work tailored to that client's needs. I'll also send original or duplicate slides to fill any specific requests immediately. Responding quickly, professionally, and with the "right stuff" in terms of photographs ensures that this new client will call the next time he has need for my type of work.

Pricing

The key to pricing lies in knowing what a reasonable rate for a photograph is. A few books give tables of standard fees for different usages based on size of the published image, circulation of the publication, and other factors. In 1984 the American Society of Media Photographers (ASMP) published the first edition of their *Stock Photography Handbook*. One section contained tables of average prices compiled from a survey of photographers. ASMP is quick to point out, however, that there is no such thing as "standard ASMP rates": These prices are only averages from a survey, and they are ten years old as well. Current prices should be adjusted for inflation and for each individual

situation. In fact, the new edition of the *Stock Photography Handbook* has no such lists. Many photographers now refer to *Negotiating Stock Photography Prices* by James Pickerell, a guide to pricing that includes tables similar to ASMP's old ones, with adjustments for inflation. I highly recommend this, as photographers need to keep their prices at a reasonable level.

I keep copies of these standard price sheets near the phone and refer to them constantly when negotiating with clients over fees for an image they have already selected. My stock agency has a similar list of prices, and many editors and art directors refer to these price sheets for the "ASMP rates." Each party should get a feeling of a fair and reasonable deal. Many magazines pay a standard fee that is published and available for the asking.

Using a Stock Agency

The stock agency, in its simplest form, is a library of photographs from several contributing photographers, which may range from three to hundreds. Agencies may specialize in as many types of work as there are photographers. The agency is not a rep; agencies rarely negotiate or find assignments for participating photographers. Agencies simply sell the rights to use a particular photographer's images at rates and methods of their choosing. Ownership and copyright of the photographs deposited in the stock agency's library remain with the photographers. The idea behind a photographer-stock agency relationship is simple: The photographer sends periodic submissions to his agency, from which the agency makes selections for its files. With these images in their library, the stock agency makes sales, which are split fifty-fifty with the photographer. Some agencies differ in the split, but fifty-fifty is standard in the industry.

The photographer invests in time and expenses in producing the photographs, and the agency is responsible for the costs of doing business on their side. In an ideal relationship, the stock agency actively markets the photog-

rapher's work, leaving the photographer free to pursue assignments or other activities. Both parties benefit, and the stock agency may provide anywhere from 1 to 100 percent of the photographer's gross income.

To many photographers, the idea of having stock photographs bringing in money with little effort on the photographer's part is enticing. Often, however, a relationship with a stock agency can take a great deal of time on the photographer's part and lead to few or no sales. Shooting for stock is as difficult as assignment photography, if not more so. A good stock photograph must exemplify the most ideal values of a scene or emotion. For instance, a photograph of a couple walking along the beach of a tropical island, if it is to be sold continually as stock, must show clear, blue water; clean, fine white sand; and an attractive couple dressed in nondatable fashions. In order to compete with similar scenes, this photograph must be perfect in every detail, both technically and aesthetically. Stock photography at its best captures the essence of what an art director, editor, or customer envisions of paradise, togetherness, or

These calendars (Life in a Kelp Forest *and* Ocean Worlds*), two of my first publications, were issued in 1988 by Pomegranate Calendars & Books. The calendar publishing business is an extremely competitive field, both for the publishers and for the photographers who wish to see their work featured in these glamorous publications. When I first began looking for ways to sell my underwater photographs, the calendar market was a natural one to target.*

Paper products publishers are inundated with queries and material from photographers. A professional, clear, and dramatic presentation of your work is therefore absolutely necessary to catch the publisher's attention. As with most photographic projects, a collection of pretty pictures is usually not enough. These pretty pictures will be most effective if they are packaged into a thematic proposal, each photograph related to the others through captions and a unifying theme. For example, I first contacted the calendar company with three proposals. The one that caught their attention was titled Life in a Kelp Forest, *and it was accompanied by a detailed caption sheet describing the natural history of the kelp forest and a suggestion of markets to which this title would be applicable. They eventually decided to publish two calendars featuring my underwater photography in the same year. One was a large, fine-arts calendar about the kelp forest, and the other was a smaller, more generic underwater calendar. Calendar titles are not published until two to three years after they are first conceived, so be patient.* Artwork © 1988 Pomegranate Calendars & Books.

All of these photographs (from Life in a Kelp Forest*) were present in my proposal to the publisher. They all dealt with the central theme, and because of this thematic proposal, my idea was accepted over collections of pretty pictures with no theme. All of these photographs were taken with the same equipment: a Nikonos camera with extension tubes and small strobe.*

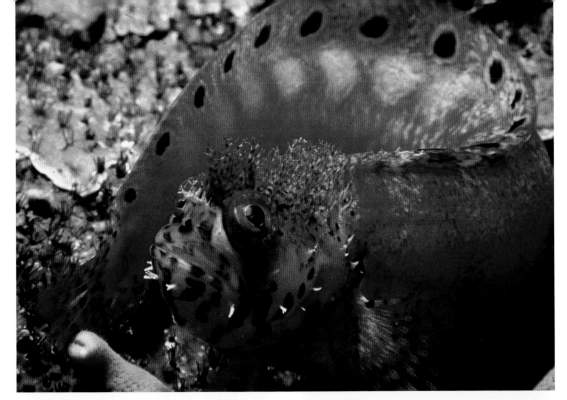

Deep-sea angler fish, San Diego, California. *Canon T-90, Canon 50mm macro lens, tungsten lighting, Fujichrome 50, 1/4 sec., f/11.*

Well-done portraits of animals that show bizarre or humorous expressions always do well. I never cease to be amazed at the selling power of this photograph. It is almost invariably chosen to illustrate stories on deep-sea life. One of my present agents used this shot in a catalog of photographs called The Stock Workbook, *which showcases the best that stock agencies have to offer in their files. Art directors and designers often use catalogs such as this one to stimulate ideas and select photographs for their projects. Many agencies are now producing their own glossy, expensive catalogs, which they hope will enhance sales of any photographs included and provide greater business for the agency. Costs of being included in these catalogs vary from agency to agency.*

strength. To produce successful stock, a photographer must keep up with trends and market analyses to be aware of what makes a successful stock photograph.

The easiest way to become accepted at just about any agency is to shoot what you love. Shoot your favorite subject or type of photograph better than you've ever seen. When you have developed a significant number of great images, from one hundred to five hundred, approach an agency with your specialty. If your specialty is in demand at that house, they will invite you in. The problem then becomes finding an agency that will actively market your images rather than sitting back and waiting for requests. For example, the specialty of underwater photography is practiced full-time by only a few photographers in the world. Nearly every agency I have ever approached has offered me a contract. But most agencies get only a few requests a year for underwater material. No self-respecting agency ever wants to turn down business, so having underwater material in their files helps them when those infrequent requests come in. For the photographer, however, an agency that actively pushes his material will work out much better.

Your relationship with the stock agent should be thought of in terms of years, not months. It takes at least two years for photographs to start making money in a stock agent's library. It is also up to the photographer to keep submitting fresh material and to keep abreast of market trends. The better stock agencies work closely with their photographers to critique their work, market and duplicate their best work for worldwide distribution, advertise their work, and inform them of frequently requested or needed photographs.

Business practices and work philosophies differ with each stock agency. Contracts can vary from a handshake or telephone agreement to a twenty-page tome. One New York agency charges its photographers $2 for every photograph that is accepted for their files. Another agency in California charges $8500 for the

Diver Deanna Mah with school of yellow snappers, Grand Cayman Island. *Nikonos V, UW-Nikkor 15mm lens, Ikelite 150 strobe at half power, Kodachrome 64, 1/60 sec., f/8.*
 Photographs of divers and snorkelers happily frolicking about in warm, crystal-clear water, surrounded by colorful fish, are always in demand by ad agencies and magazines that need to promote their tropical destinations. Only experienced divers will know that the model is in imminent danger of being eaten alive.

Sand tiger shark, Steinhart Aquarium, San Francisco. *Nikon 8008s in Stromm housing, Nikon 24mm lens with + 2 diopter, Ikelite Ai strobe on TTL, SR2000 slave strobe, Koda-chrome 64, 1/60 sec., f/16.*

Sharks are always big sellers, both for the editorial market and the generic stock market. Any photograph that can symbolize a human trait or make the viewer feel an emotion will do well in the marketplace.

costs of duplicating and sending five hundred of a new photographer's best images to their many foreign subagencies. Many agencies purchase advertising pages in catalogs such as *The Stock Workbook*, and quite a few are now putting out their own catalogs, filled with work representing their photographers. Most agencies share the cost of this promotion with the photographer. The best of them will pay for the catalogs in advance and deduct the expense from future earnings of the photographer.

Some agencies demand exclusivity—that a photographer have work on file only with that particular agency. My feeling is that stock agencies have too much of a good thing. They are demanding exclusivity from their photographers, but they rarely promise anything in return—not money, and not even the promise of limiting the number of photographers in the agency, or in your specialty.

One worrisome aspect of any stock agency

relationship is the fact that none of them carry insurance for the photographs in their care. Insurance is just too high for them to cover your photographs, and as a consequence, photographs that are lost or damaged at the agency are rarely compensated for.

I believe that the increasing presence of stock agencies is actually having a detrimental effect on the business of the nature photographer. They are taking bread-and-butter business away from photographers by selling photographs at cut-rate prices, in large bulk deals. Individual photographers are left handling the hard-to-get-requests from publishers who expect usage fees to match those of the cut-rate stock agencies. I have been appalled at how low my photographs were sold by one agency in particular. It was this agency that initially promised the world to me and that required a monumental investment of time to caption each image its way. This agency asked me to submit my very best images, and it wanted exclusive rights to represent my work. Fortunately I was very careful, holding on to my best images and only agreeing to a nonexclusive contract. I did spend hundreds of hours captioning my slides its way and filling its requests, however, even going to the extent of shooting stock for its want lists. After four years, this agency has performed worse than any of my others. It required more time than any other

Common dolphins, Sea of Cortez, Baja, California. *Canon T-90, 24mm lens, Fujichrome 100, 1/250 sec., f/5.6.*

Marine mammals such as whales and dolphins have been recurring best sellers. The problem is that so many good photographs of these animals have been taken. To reach the level of the current playing field, it is necessary to spend months photographing these unreliable, fast-moving, and politically-charged animals.

Amazon River dolphin, Pittsburgh Aqua Zoo. *Nikonos V, UW-Nikkor 35mm lens, Aquaflash strobe at quarter power, Ektachrome 64, 1/60 sec., f/5.6.*

The other approach to marine mammals is to photograph the less common species, the ugly ones that no one else thinks about. These photographs are in demand by book publishers wishing to show the range and diversity of cetaceans. This photograph has probably sold as well as the one on the previous page.

activity last year but only did about 1 percent of my gross. In short, this agency promised great things, asked for a great deal of time and material, yet has never delivered. I would be out of business now if I had believed this agency's promises, given in to their requests for exclusivity, and let my best photographs out of my office.

Yet another problem with agencies is their increasing reliance on forming networks of subagencies in different countries. Many stock agencies will take your photographs and send them to foreign subagencies. The primary stock agency does little other than reroute your photographs to a subagency, yet it retains 50 percent of usage fees that result after the subagency takes its cut. The photographer may end up with as little as 25 percent of the gross sale.

Many aspiring photographers, upon hearing of photographs being sold for thousands of dollars, have a distorted view of the business of stock photography. In truth, the business of selling your stock photographs is tedious and time-consuming whether you use an agency or sell stock directly. I choose both avenues, because I want to sell my images to as many places as I can to make as much money as I can. And most importantly, I want to have fun doing it.

Of course, there is nothing like working for yourself, seeing your work in print, and seeing new photographs on your light table. With hard work and a good eye, it is possible to make a good living at this profession. A good friend of mine recently sent me a cartoon captioned "The Advantages of Being Self-Employed." The picture showed a man sitting at his desk with a big grin on his face and twelve framed photographs of himself behind his desk. Each photograph was labeled "Employee of the Month."

Different clients look for different things from a photographer. Every underwater photographer working today has his own special niche. Some clients, such as magazine and textbook publishers, need photographers with an extensive knowledge of natural history. Other clients, such as those in the advertising industry, couldn't care less about the behavior of snails but are always on the lookout for someone who knows how to shoot tropical islands. The commercial photographer requires the knowledge of, and more importantly the interest in, dressing and setting up models. Other photographers make their living by teaching, selling art posters, or filming for television.

Camera Maintenance

Routine Procedures

Putting metal parts, particularly expensive metal and electronic parts, into salt water is a bad idea. Dissimilar metals, such as stainless steel screws fitted into an anodized aluminum plate, will soon bond together through electrolysis. The slightest drop of sea water on a camera's electronics or shutter mechanism will destroy that camera.

The best way to care for underwater photographic equipment, other than reading and following the instructions in the manual, is to soak the gear in a tub of fresh water immediately upon surfacing from a dive. Periodically, every few days or so if you are diving daily, or when storing or taking cameras out of storage, grease the O-rings and take apart moving parts on cameras and housings. Don't bother greasing O-rings more than once every few days; it does seem that the more time that is spent greasing rings, the more susceptible a camera is to flooding. One of the more useful tools in my kit is a nylon guitar pick, which I use to pick O-rings out of their seats. Every camera and housing has a number of internal O-rings that cannot be serviced yourself. I have my cameras, underwater lenses, and housings serviced every five years rather than every year as some people recommend.

The silicone grease used to coat O-rings is intended only to keep the rubber supple. The grease itself does not have anything to do with sealing the camera from water. In fact, putting excessive amounts of silicone grease on an O-ring increases the likelihood of that camera flooding, as excessive grease will attract sand, hair, and other particles that can break the integrity of the O-ring seal. Sand can be a camera's worst enemy. Because of this, I no longer dive from beaches, for carrying a camera through surf will inevitably cause fine grains of sand to lodge in every conceivable crevice and seal of your camera or housing. These sand grains may eventually work their way into the seal and compromise it. Another way to cause an eventual flood is to allow salt water to dry out in gear in the hot tropical sun. The salt crystallizes on parts and O-rings, and scratches and dries out internal O-rings.

O-rings function by creating a seal that gets stronger at depth. The O-rings around a housing or in a camera back are squeezed tighter, forming a true seal, as the camera is brought down to depth. The most dangerous time for a housing or amphibious camera is in shallow water, where little pressure is on the seal. This is why I don't recommend hanging cameras over the side of a boat while putting gear on. For the same reason, I also don't recommend keeping gear in a saltwater bucket in lieu of a freshwater rinse. The best thing to do is to soak the camera in fresh water immediately after coming out of the water, then take it out after a few minutes to avoid flooding. Every few days, rinse the camera thoroughly, shake it around in a freshwater bath, and move the controls around so that fresh water can displace salt water.

When changing a lens on the Nikonos camera, I always hold the camera face down, so

that water from the lens drips down rather than onto the shutter of the camera. The shutter blades in any camera are particularly vulnerable to corrosion. If a drop of water gets on the shutter, immediately dab with a tissue or Q-tip to absorb the water. Don't wipe or exert any kind of pressure on the delicate shutter. When changing film in the Nikonos camera, I always open the back door so that it swings down. I then wipe the entire inner surface of the camera with a tissue or, more often, my shirttail. The foam areas around the seal on the Nikonos only serve to absorb water, so it is important to wipe up the drops of water that are left behind by the O-ring.

I use a fifty-fifty water and vinegar solution to clean the corrosion off any electrical contact that has been in contact with salt water, such as my male and female EO and Nelson strobe connectors. Something I've learned through hard experience is to clean lenses only when absolutely necessary. When cleaning a lens, use a blower (a large blower from a local drugstore works just as well as canned air) to blow off any small particles and grit. Using lens tissue softened by a drop of lens-cleaning fluid, wipe the lens in a circular motion. Use another tissue to dry off the lens, again wiping in a circular motion, and taking care to wipe gently. Lens surfaces are quite delicate and can easily be scratched.

Film's worst enemies are heat and humidity. Don't leave the camera in the sun. It will

Diver with shark suit and blue shark, open ocean off San Diego, California. *Nikonos V, UW-Nikkor 15mm lens, Ikelite 150 strobe at half power, Kodachrome 64, 1/60 sec., f/5.6.*

Many a camera has been well-maintained and lovingly cared for by its owner, only to be rudely shoved into the mouth of a shark.

quickly get hot, and in the tropics, the temperature can rapidly reach 120 degrees inside the camera. There will be a condensation problem if it is then brought into an air-conditioned room. The lens will be most affected by condensation. Don't open the camera until the entire body has cooled to room temperature. Conversely, bringing a cold camera into tropical heat will cause the lenses to fog up. The solution is to encase your cameras in a plastic bag. As the camera warms up, the condensation will form on the bag, not the camera.

Emergency Rinsing

Today's electronic cameras rarely survive a flood of salt water. The Nikonos I, II, and III bodies and the older mechanical camera bodies such as the Nikon F2 and the Canon old-style F-1 can come away from a dunking with no ill effects at all. I've saved my mechanical F-1 camera by rinsing it thoroughly in distilled water (tap water has too many minerals in it), then drying it by placing it in the engine room of the boat I was on—a hot, dry area. Alternatively, you can place the camera in an oven on low heat with the door open or keep a hair dryer on it. Let the camera dry for twenty-four hours. I've actually used a camera saved this way the next day, then sent the camera in for an overhaul at the end of the trip. It still works. Don't use alcohol, vinegar, or WD-40. If no distilled water is available, tap water will suffice until the camera can be serviced by a professional. With the Nikonos V camera, dip the camera in water up to the electronics plate, which is just below the viewfinder. Take care not to turn the camera over or to get water in the viewfinder or on the LEDs in the viewfinder.

Advanced Topics

Pushing Films

By pushing a film, you are able to use it faster than its rated ISO. For example, photographers often push Fujichrome 100 film one stop, to ISO 200. By doing so, they are able to use this film as they would use a higher-speed film. All that remains is to tell the processing lab to "push-process the film." There is a tradeoff, of course: A film that is pushed is grainier and less saturated than normal. Fujichrome 100 pushed to ISO 200 gives good color saturation and grain, however, and gives better results than using the old Ektachrome 200 or 400 at their rated speeds. All E-6 films can be pushed up to two stops by a professional lab. Push-processing can be done in increments of as little as a quarter stop.

Unknown to many photographers, Koda-chrome can also be pushed. I have sometimes mistakenly exposed Kodachrome 25 film at ISO 64, a push of one and a third stops. The result-ing pushed film looks very good in terms of both grain and color saturation. There is little reason to push a film, though, unless a high-speed film is needed and none is available. I have sometimes gone underwater with a cam-era and found that light levels beneath a kelp forest are too low to register on the film I'm using. By pushing the film one stop, I am able to save the dive. Pull-processing a film is possible also and is sometimes used to decrease grain and contrast in a film. Each film reacts differ-ently to push- or pull-processing, and it is neces-sary to test films in order to find out what the results will be like.

Advanced Flash Techniques

In underwater photography two light sources are usually present: ambient and strobe. The aperture for ambient light is determined by a separate light meter such as the Sekonic Marine Meter, while that for strobe light is de-termined by previously measured guide num-bers. For close-ups, strobe usually provides all light. Wide-angle situations, however, use both ambient and strobe light. Two exposures actu-ally register on the film: one of the subject, lit by flash of short duration (1/10,000 to 1/2000 second), and one of the background, lit by sunlight.

In most situations, balancing available light with strobe will create more pleasing, natural photographs. Photographs of animals in their natural surroundings are often more dramatic and appealing than those with black back-grounds. When photographing fast-moving animals, however, trying to create a balanced photograph will cause a phenomenon called ghosting, in which the image of the animal is blurred. The fast burst of light from the strobe freezes the image at one point in the frame, while the ambient light causes another expo-sure.

One solution is to use a high shutter speed. With these large, fast-moving marine mam-mals, the standard speed of 1/60 second is often too slow. Setting the shutter speed to 1/125 second or higher will freeze the subject's motion more satisfactorily. Also, at these higher shutter speeds, the shafts of sunlight streaming through the water will appear more

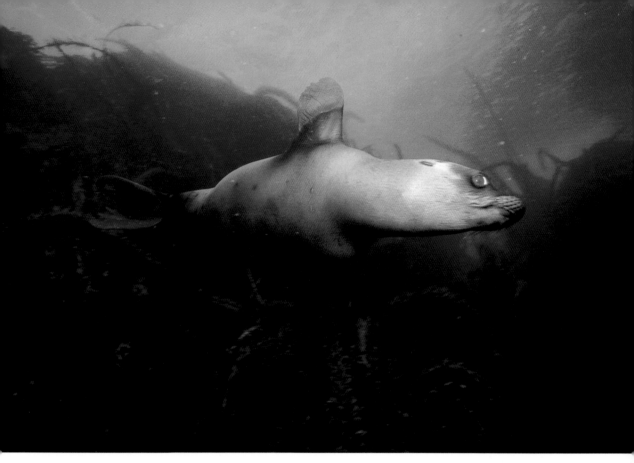

Fast-moving sea lion, Coronados Islands, Mexico. *Nikonos V, UW-Nikkor 15mm lens, Ikelite 150 strobe at half power, Kodachrome 64, 1/60 sec., f/4.*

This sea lion whizzed past me at high speed. It was moving so fast that the combination of flash and ambient light created blurring, or ghosting.

definitive, contributing to the dramatic impact of the photograph. The only problem here is that strobe can't be used at these higher shutter speeds with cameras like the Nikonos V. With the newer electronic cameras with flash sync speeds of 1/125 or 1/250 second, ghosting is less of a problem.

With the Nikonos V camera, there is still a solution to the problem of ghosting. The Bank technique, named after its creator, photographer Marjorie Bank, makes use of strobe at shutter speeds faster than the camera's rated sync speed in order to freeze fast-moving subjects. Shutter speeds are created by two curtains following one another. Sync speed is the fastest shutter speed at which both curtains do not cover the frame of the picture area at the same time. I have already mentioned that strobe light lasts for a very brief duration, about 1/4000 second. With the Nikonos V, at 1/90 second and slower speeds the entire frame is open during the brief instant the strobe flashes and thus is exposed to the strobe light. At higher shutter speeds, however, part of the frame will be covered by one of the curtains at all times; the curtains follow each other more closely to create the faster shutter speed.

Understanding this will enable you to use a faster shutter speed with strobe. In the Nikonos V, the shutter curtains travel up the frame, fol-

Yellow submarine amid sun rays, Tongue of the Ocean, Bahamas. *Nikonos V, UW-Nikkor 15mm lens, no strobe, Kodachrome 64, 1/250 sec., f/5.6.*

Using a high shutter speed in the range of 1/125 second and faster will help freeze the motion of light rays through the water, creating dramatic backgrounds.

lowing each other from bottom to top. At 1/125 second, the top three-quarters of the frame is open when the strobe fires, but the bottom quarter of the frame is not exposed by the strobe. If you keep your strobe-illuminated subject in the upper part of the frame, all will look normal, whether the background is lit by ambient light or black. In the photograph of the sea lion, the Nikonos V was tilted on its side to create a vertical composition. The sea lion was placed near the top half of the frame, and a shutter speed of 1/125 second was used. Note how the motion of the sea lion has been frozen by the high shutter speed.

Other cameras may work differently. For example, the shutters in the old-style Canon F-1 travel across the frame from left to right. The photographs of the map on page 107 show how part of the picture area progressively remains unexposed by the strobe as the shutter speed is increased. At 1/250 second, fully half of the picture area is blacked out; at 1/500 second, nearly all of the frame is blacked out. If there is enough ambient light, the blacked-out portion of the frame will be unaffected by the strobe light but will show ambient background.

If you use a Nikonos V camera with dedicated strobe, the shutter locks at 1/90 second if you choose any shutter speed above 1/90. You must bypass this TTL circuitry by switching the strobe to manual or by using a manual flash connector such as an EO or Nelson adapter.

Blue-water diver and open-ocean array, Northern Pacific Gyre. *Nikonos V, UW-Nikkor 15mm lens, no strobe, Kodachrome 64, 1/250 sec., f/5.6.*

By pointing my camera straight down into the clear waters of the Northern Pacific Gyre, I was able to capture the motion of sunlight as it disappeared into the bottomless depths. A fast shutter speed helped to define the lines of light clearly.

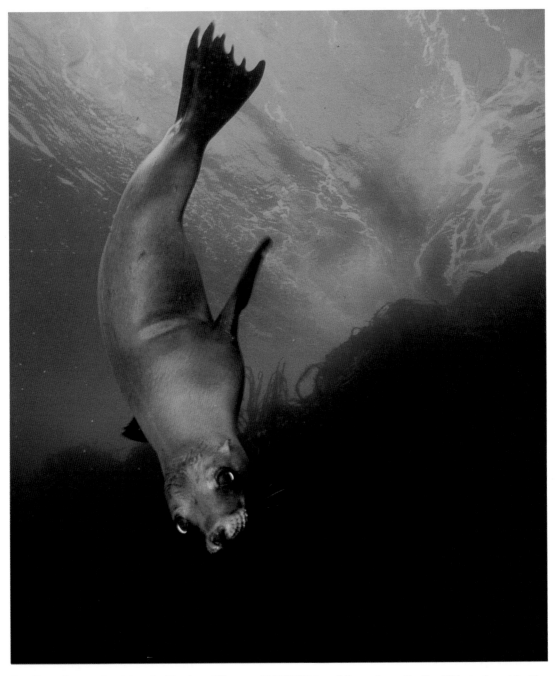

Sea lion, Coronados Islands, Mexico. *Nikonos V, UW-Nikkor 15mm lens, Ikelite 150 strobe at half power, Kodachrome 64, 1/125 sec., f/4.*

By understanding how my Nikonos syncs to strobe, I was able to freeze the motion of this sea lion. Strobe light froze the motion of the animal, and the faster shutter speed of 1/125 second prevented ghosting.

Map of the world. *Nikonos V, UW-Nikkor 35mm lens, Ikelite 150 strobe on half-power, Kodachrome 64, 1/250 sec., f/8.*

In this photograph, strobe provides all light. The shutter speed was intentionally set at 1/250 second, much higher than the 1/90 second sync speed of the Nikonos V. As a result, the bottom of the photograph has received no light from the strobe and is black.

Map of the world. *Nikonos V, UW-Nikkor 35mm lens, Ikelite 150 strobe on half-power, Kodachrome 64, 1/500 sec., f/8.*

At 1/500 second, the top and bottom shutter curtains of the Nikonos V camera follow each other very closely. When the strobe fired, only the very top of the frame was not covered by the bottom curtain.

Map of the world. *Canon F-1, Canon 50mm macro lens, Vivitar 283 strobe, Kodachrome 64, 1/125 sec., f/8.*

The shutter curtains of the Canon F-1 camera follow each other from left to right, rather than from bottom to top. At 1/125 second, the second curtain is just beginning to enter the frame, blocking off strobe light from the left side.

Map of the world. *Canon F-1, Canon 50mm macro lens, Vivitar 283 strobe, Kodachrome 64, 1/250 sec., f/8.*

At 1/250 second, the second curtain fully blocks half of the frame.

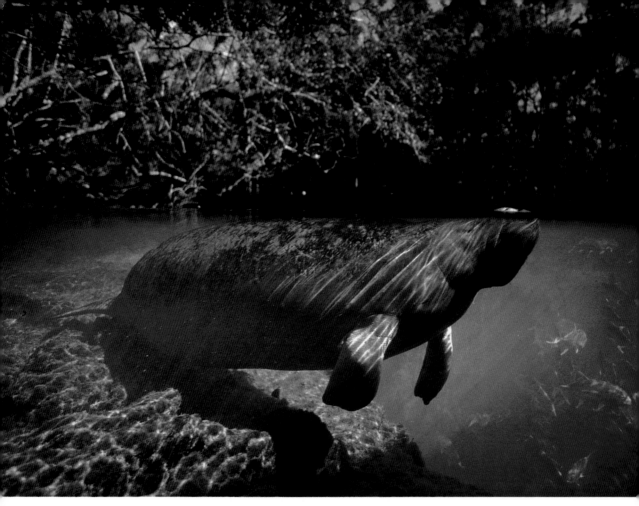

Manatee, Homosassa Springs Wildlife Park, Florida. *Nikon F4 in Aquatica housing, Nikon 18mm lens with over/under filter, no strobe, Kodachrome 64, 1/60 sec., f/5.6.*

 These manatees, injured animals being cared for by a wildlife park, were docile and allowed me to get within inches of them. A graduated neutral density filter cut down light above water, so that both over- and underwater scenes were within a stop of each other. A +2 diopter cut in half allowed the lens to focus on the underwater subject while maintaining some detail in the topside scene.

Over/Under Shots

A turtle swims past a bright coral reef, while swaying palm trees on a South Pacific island frame the horizon. This scene is easily imagined but rarely captured in a photograph. Photographs that show both underwater subjects and topside scenes in the same shot are called over/under shots. These unusual shots show the two facets of our planet, earth and water, in an eloquent way. They can, however, seem gimmicky if used too often.

 The key to taking this kind of shot is a wide-angle lens mounted on a housed SLR camera. In order for a wide-angle lens to perform adequately underwater, you must use a dome port on the housing, as opposed to a flat port, which

will cause pincushion distortion. You must also use manual focus, as autofocus will not work behind the special filter needed for this type of shot.

The dome port when used underwater acts as a second lens, creating a "virtual image." The virtual image of a subject at infinity is located at a distance from the lens that is twice the diameter of the dome port. The wide-angle lens must be able to focus at least this close. The closer the wide-angle lens can focus, the better the focusing range of the housed system underwater. The most frequently used focal lengths for over/under shots range from 16mm fisheye to 24mm lenses in a housing behind an eight-inch-diameter dome port. In order to capture images at infinity underwater, these lenses must focus to within sixteen inches (twice the diameter of the dome). To be able to focus on objects closer than infinity, you can use a close-up diopter.

The over/under shot thus presents a problem: If a lens is focused on an underwater scene, it will not be focused on a distant topside scene, such as clouds overhead or a far-off island. Instead, it will be focused topside at sixteen inches from the dome or closer. Using a wide-angle lens will allow for greater depth of field, but this is not usually enough.

There are many approaches to this problem. Using a 16mm full-frame fisheye lens, which has a 180-degree field of view and a correspondingly great depth of field, will allow both the underwater and topside subjects to be in focus at the same time. The problem with this lens is that it is so wide. Objects that are not exceedingly close are rendered terribly small in the photograph. This lens should be used sparingly on land because of the gimmicky look it can give a photograph. It is expensive and bulky, and you cannot use screw-on filters on the lens, since they will cause vignetting. Without using a neutral-density filter, you will not be able to balance the light between water and land. One solution is to cut a neutral density gel into a semicircle and tape it over the lens.

Many photographers prefer to invest their money and baggage space in a lens they can use in many different situations. A good compromise is a Canon FD 17mm lens, which has a 110-degree field of view (Nikon makes an equivalent 18mm lens). If this lens is set at f/8, the zone of focus ranges from two feet to infinity. To focus sharply on an underwater scene, however, focus must be closer than two feet, and so the corresponding zone of focus is decreased, rendering topside landscapes out of focus.

The solution here is an inexpensive Cokin filter called the split-image filter—simply a close-up diopter that has been cut in half. The professional variety (P) of Cokin filter is preferable to the amateur variety (A). The P filters are larger than the A and will fit the larger filter sizes of lenses such as the 17mm. Get a Split-field +1 diopter (#P111) or one of the higher diopters.

Cokin also makes a series of filter adapter rings that attach the filter holders to the front of the lens. Get the size to fit your lens; for example, the Nikon 18mm and the Canon FD 17mm lenses have a 72mm thread, so a Cokin 72mm filter ring, which simply screws into the front of the lens, serves as an attachment point for the split-image filter. Unfortunately, this split-image filter comes with a very large holder. This is fine for topside photographs, but in the close confines of an aluminum housing this filter holder gets in the way. To make a simpler filter mount, take the half-moon crescent of glass out of the holder and glue it to the filter holder with clear epoxy resin. This gives you a ring that mounts on the front of the lens. Place the diopter side on the bottom of the lens so that it will be in the underwater part of the photograph, bringing underwater scenes into focus. At the same time, the topside scenes also will be in focus, as the zone of focus at f/8 ranges from two feet to infinity. This split diopter will render both underwater and topside scenes in focus. Using a shutter speed of 1/125 second is opti-

mal; the subjects will be sharp and there will be good depth of field.

The next problem to overcome is the difference in light between underwater and topside scenes. This is easily solved. If the underwater subject is close enough and its background is not important, an underwater flash can be used to light the subject. This will balance the light level on the subject underwater with that above water. This is the only way to balance light levels when using a fisheye lens, which cannot accommodate normal front lens filters. If your underwater subject is something like a coral reef, however, it is impossible to light up the entire underwater scene. In this case, you use a graduated neutral density filter. This filter is clear on the top half, gradating to a dark tone on the bottom half. Ambient light underwater is usually two stops below topside light. A graduated neutral density filter oriented correctly will cut topside ambient light down two stops, to the same level as the underwater scene.

Cokin makes several types of graduated neutral density filters, in several colors and intensities. The most common is a straight, neutrally colored (gray) filter that cuts the light down one or two stops. It comes in gradual G1 (one stop, #P120) and G2 (two stops, #P121). To give the topside half of the scene a brighter look, you can use the G1 filter, which cuts light down by one stop only. A good optician can take the large, square filter Cokin supplies and cut it so that you can glue it inside the circular filter ring. In this way, the filter is a compact one-

Granite islands and casuarina trees, Seychelles Islands. *Canon F-1 in Oceanic housing, Canon 17mm lens with over/under filter, no strobe, Kodachrome 64, 1/60 sec., f/5.6.*

These granite islands in the Seychelles Islands were easy, photogenic subjects.

Coral reef and palms, Fiji. *Canon F-1 in Oceanic housing, Canon 17mm lens with over/under filter, no strobe, Kodachrome 64, 1/60 sec., f/5.6.*
Taken in a lagoon, this photo shows the coral reef and palm trees, typical of a South Seas island.

piece combination of two pieces of glass on the metal filter ring and can be quickly screwed onto the lens. Some photographers use a polarizer instead of a neutral density filter.

In general, the over/under shot is a difficult shot to get right. The water must be absolutely still and calm for the best results; the slightest wave or chop will cause problems. As in all wide-angle photography, it is good if subjects are close and have an interesting background, such as a deserted island or storm clouds on the horizon. If you are working with the Canon FD 17mm lens, you'll find that you have a problem other photographers don't have to put up with: The front element of this lens rotates as it is focused. This means you must adjust the filter orientation each time you change the focus, and so you can't refocus while in the water or even halfway in the water. With this lens, you

must adjust the lens settings before getting in the water and shoot everything without readjusting. The front of the equivalent Nikon 18mm lens doesn't rotate, so this problem doesn't occur. If you're using a Nikon system in a housing, you'll be able to change focus while in the water, thus heightening your chances of success.

If the lens already focuses close enough for underwater use, you can use a negative diopter (-1, -2, or -3) instead of a close-up diopter. This diopter will bring the topside half of the image in focus while the lens is focused on the underwater virtual image located at sixteen inches or less. If a lens has been matched to a dome for underwater use, this diopter will maintain the optical integrity of the lens-dome configuration and will give sharper underwater images than using a close-up diopter.

Making Green Water Blue

Some of the best diving is to be found in our backyards: in lakes, near rivers, and off beaches. But since these waters are so close to the mainland, they are often green from the presence of algae, which grows in nutrient-filled waters close to mainland runoff. In underwater photography, blue water is generally preferable to green, since most people asso-ciate ocean diving and the underwater realm with clear, blue water. Here are ways to make green water blue:

• Use a cyan-biased E6 film. Using a film that tends toward cyan will give bluer water backgrounds. Use Ektachrome or Fujichrome film instead of Kodachrome. Both of these films have reputations for being blue, or cyan, biased, and they will produce a more pleasing blue water background in green water than will Kodachrome. Using Fujichrome in tropical waters that are already blue will create a much more powerful blue. Some photographers find this objectionable, while others like the intense color. In some cases, it also will make foreground subjects such as divers appear bluer than if Kodachrome were used. I generally use Fujichrome films only in greener waters. In tropical locations I already have more blue underwater than I need, as sea water filters out yellows and reds within ten feet, so I tend to stick to Kodachrome.

• Use film that is balanced for use with tungsten lights rather than standard daylight-balanced film. Almost all films used in underwater photography are daylight-balanced films. Regular daylight-balanced film, such as Kodachrome 64 and Fujichrome 100, is designed to render true colors in sunlight, while tungsten-balanced film is designed to give natural renditions of subjects lit by tungsten lights (such as household lamps), which give off an orange color. Amateur photographers often make the mistake of using daylight-balanced film to photograph subjects inside buildings, which are lit with tungsten lamps. When they do so, the lighting appears orange, and people and other subjects lit by the tungsten illumination appear unnaturally reddish. On the other hand, if tungsten-balanced film is mistakenly used outdoors or with strobe lighting, even worse coloration occurs—the people look blue! When used properly, tungsten film underwater can render green backgrounds an enticing blue.

Professionals who are familiar with the prop-

Baby turtles attracted to tungsten lighting, Sangalakki Island, Borneo. *Nikon 8008s in Stromm housing, Nikon 24mm lens, SB-24 strobe, Kodachrome 64, 15 sec., f/11.*

In this photograph I left the camera's shutter on for a full 15 seconds, trying to show the effect of lights on baby turtles. The foreground is lit by my SB-24 strobe, which is daylight-balanced, as is the film. The doorway is lit by tungsten lighting, which is yellow in color.

Diver Spencer Yeh with pelagic jellyfish, Monterey, California. *Nikonos V, UW-Nikkor 15mm lens, Ikelite 150 strobe at half power, Kodachrome 64, 1/60 sec., f/4.*

This photograph shows the water very close to its actual green color. If I had used Fujichrome film rather than Kodachrome, the water would have looked more pleasingly blue. These jellies can reach twenty feet in length. Including a diver to show scale really makes this picture, despite the green water. Using a wide-angle lens and positioning the diver a few feet behind the jelly makes the jellyfish look even bigger than it actually is.

Photographer Bob Cranston with pelagic jellyfish, Coronados Island, Mexico. *Nikonos V, UW-Nikkor 15mm lens, Ikelite 150 strobe at half power, Fujichrome 100, 1/60 sec., f/5.6.*

This photograph shows the blue bias of Fujichrome film. Green water becomes noticeably bluer in photographs taken with E-6 based film.

Divers filming PBS *Nature* sequence using tungsten lights, Coronados Islands, Mexico. *Nikonos V, UW-Nikkor 15mm lens, no strobe, Fujichrome 100, 1/60 sec., f/5.6.*

Filmmakers have long relied on tungsten-based lamps to provide continuous light sources for filming. These tungsten lights are orange in color, and the tungsten-balanced film has been manufactured to render subjects lit by this orange light to appear natural in color. Consequently, subjects lit by natural sunlight, such as water in the background, will appear blue in color.

erties of their light sources and film can use the various films to their advantage. Many dark evening scenes have been taken with tungsten film to enhance the blue color of twilight. Professionals often use daylight film at night to photograph buildings lit by tungsten lights; the resulting images are suffused with a warm, orange glow. The knowledge of color films and their behavior under different lighting can also be applied underwater.

Underwater filmmakers (as opposed to still photographers) have long been forced to use tungsten lights and therefore tungsten-balanced film for their work. The older underwater films you may see on television often suffer from colors and film that are not matched properly. The foreground subjects, which have been lit by tungsten lights, typically look reddish, while the water in the background, particularly with films shot in tropical waters, looks unnaturally blue. On the other hand, underwater films shot off California or in other waters that are not as brilliantly blue as the tropics often look more natural. The colors are truer, and the water backgrounds are a nice, subdued blue.

When tungsten-balanced film is used underwater, it makes everything lit by daylight appear blue. It does the same thing with green water. The foreground subjects of coral and fish, which are illuminated by tungsten lights, will look natural, but the water in the background, which is lit by sunlight, will appear much bluer on tungsten film.

Using standard strobes along with tungsten film will cause the subjects to look unnaturally blue. You can, however, place an amber or orange filter over the underwater strobe to change the color of the light coming out of the strobe. This will result in photographs in which the subjects are lit with natural colors but the background of water is bluer than in reality. This method of using tungsten film along with filtered strobe lights works well in green, murky water, but in clear, blue waters it will cause unnatural-looking results. If you are shooting in clear, blue water or if you want to show water colors as they actually are, you should not use this technique.

Knowing the characteristics of films and your equipment will allow you to predict their effects in various situations. It is only through constant experimentation that you will develop a sense of what to use in different situations, and for me this is what makes underwater photography challenging.

RESOURCES

Underwater Photography Equipment

The following are manufacturers of underwater photography equipment mentioned in this book. This is not a complete list. Makers of underwater gear range from large companies to small garage operations, and the quality of gear varies just as widely.

Amphibico
9563 Cote de Liesse
Dorral, Quebec
H9P IA3 Canada
514-636-9910
fax 514-636-8704
Amphibico makes a line of high-quality aluminum housings for video cameras, among the best-engineered housings on the market.

Anthis/Nexxus Housings
1-16-1 Yabuta
Okazaki, Aichi
Japan 444-21
81-564-25-3937
fax 81-564-25-2205
The Nexxus housing for the Nikon F4 camera is well designed and fits the camera like a glove. The Nexxus housing for the Nikon 8008s camera is similarly compact, but viewing the entire image from behind a mask is a problem, as no accessory viewfinder is supplied.

Aqua Vision Systems
7730 Trans Canada Highway
Montreal, Quebec
H4T 1A5 Canada
514-737-9481
fax 514-737-7685
The Aquatica line of housings for the Nikon F3 and F4 and Canon F-1 cameras are large but well designed and optically correct. Aqua Vision also makes video and strobe housings.

B and H Photo
119 West 17th Street
New York, NY 10011
orders 800-221-5622
212-242-6115
fax 212-366-3733
I, like many professionals, buy most of my gear and film from this New York mail-order house. B and H is honest, knowledgeable, and trustworthy, unlike many other mail-order firms. It has a huge selection, much more than any local camera store, and its salespeople are knowledgeable. I lament their new voice-mail system, however, which takes up five minutes before you get anywhere.

Beattie Camera
2407 Guthrie Avenue
P.O. Box 3142
Cleveland, TN 37311
800-251-6333
615-479-8566
Beattie Camera makes the Intens-screen, a focusing screen that can replace viewing screens in several camera models. It is advertised to be twice as bright as existing focusing screens, which is useful underwater, where light levels are low.

Camera Tech
1817 Balboa Street
San Francisco, CA 94121
415-387-1700
fax 415-387-8636
Geoffrey Semorile of Camera Tech is a diver, a photographer, and a wealth of information about photographic gear. His shop carries a full line of parts for housings and does custom work and repairs on any type of photographic equipment. For instance, Camera Tech can fit a Sea and Sea strobe with Ikelite bulkhead connec-

tors, so that you can use Ikelite cords with the Sea and Sea strobe. He carries a premium line of underwater lights, strobes, and arms.

Canon USA Inc.
One Canon Plaza
Lake Success, NY 11042

Charles Beseler Co.
1600 Lower Road
Linden, NJ 07036
908-862-7999
fax 908-862-2464
The Beseler dual-mode slide duplicator is one of the best on the market.

Fuji Photo Film USA
555 Taxter Road
Elmsford, NY 10523

Gates Underwater Products
5111 Santa Fe Street
San Diego, CA 92109
619-272-2501
fax 619-272-1208
Makes video housings and does custom work.

GMI Photographic/Sea and Sea
1776 New Highway
Farmingdale, NY 11735
516-752-0066
fax 516-752-0053
Sea and Sea markets a complete line of accessories for the Nikonos cameras, including several prime lenses. It also markets the Motor Marine camera, a 35mm viewfinder camera.

Helix Photo
310 South Racine
Chicago, IL 60607
800-33HELIX
fax 312-421-1586
The best source in the United States for underwater photography equipment and books dealing with any marine subject.

Hugy-fot
CH-8700 Kusnacht/Surich
Switzerland
Makes a popular aluminum housing for various cameras favored by European divers.

Ikelite
50 West 33rd Street
Box 88100
Indianapolis, IN 46208
317-923-4523
fax 317-924-7988
A source for nearly any underwater photographic need, Ikelite makes a complete line of accessories and strobes for the Nikonos system, as well as Plexiglas housings for nearly any land SLR camera ever made. Its prompt repair service is legendary in the diving industry.

Kodak
343 State Street
Rochester, NY 14650
800-237-5398

Light and Motion
32 Cannery Row
Monterey, CA 93940
408-375-1525
fax 408-375-2517
Innovative maker of video housings and underwater lighting systems.

Nikon Inc.
1300 Walt Whitman Road
Melville, NY 11747
516-547-4381
fax 516-547-0309

Oceanic Products
14275 Catalina Street
San Leandro, CA 94577
510-352-5001
fax 510-352-4803
Manufacturer of the trustworthy Oceanic aluminum housings and strobes.

Pacific Camera Service
2980 McClintock #H
Costa Mesa, CA 92626
714-850-1756
fax 714-432-0641

Complete repair service for Nikonos equipment. It also makes such custom pieces as a 250-exposure back and motor drive for the Nikonos V.

Sekonic
40-11 Burt Drive
Deer Park, NY 11729
516-242-6801

Sonic Research
P.O. Box 850
Bonsall, CA 92003
619-724-4540

Makes the SR2000 strobes, the finest slaves available.

Stromm Underwater
P.O. Box 188
Place du Parc
Montreal, Quebec
H2W 2M9 Canada
514-982-0050
fax 514-982-9225

Makes ABS plastic housings for the Nikon 8008s and Nikon N90 cameras, among others. Its viewfinder is probably the best available.

Subal Underwater Housings
P.O. Box 25
A-4406 Steyr
Austria
07252 / 46424 or 07252 / 52651

Elegant aluminum housings for the Nikon 8008s and F4 cameras.

Technical Lighting Control
238 Las Alturas Road
Santa Barbara, CA 93103
Phone and fax 805-965-4951

Makers of the best strobe arms in the business.

Tussey Underwater Systems
5724 Dolphin Place
La Jolla, CA 92037
619-551-2600
fax 619-551-8778

Makes a compact housing for the Nikon 8008s camera.

The Stock Solution
307 West 200 South #3004
Salt Lake City, UT 84101
800-777-2076

Sells self-sealing mounts and caption labels for all formats of transparencies.

Tiffen Filters
90 Oser Avenue
Hauppauge, NY 11788
800-645-2522
516-273-2557

Underwater Photo-Tech
16 Manning Street, Suite 104
Derry, NH 03038
603-432-1997
fax 603-432-4702

Repairs and manufactures accessories for the Nikonos cameras.

Recommended Reading

ASMP Stock Photography Handbook, 1st and
 2nd editions
American Society of Media Photographers
 (ASMP)
419 Park Avenue South
New York, NY 10016

Absolute musts for any photographer's bookshelf. The first edition (1984, not in print) contains an invaluable pricing section that gives usage fees for photographs depending on the type of publication, the circulation or size of printing, and size on the page. Unfortunately, you will have to beg, borrow, or steal this edition from a veteran photographer. The second edition (1990) is more up-to-date, but instead of giving specific prices, it devotes a chapter

to negotiating and pricing your photographs. Both editions contain listings of stock agencies in the United States and abroad. Both are invaluable for determining the worth of your work and gaining an overview of the stock photography business. ASMP is a photographer's association and a worthy advocate of photographers' rights. By joining the society, you will receive monthly newsletters and bulletins and keep up-to-date on business issues.

Nature Photographer Magazine
P.O. Box 2037
West Palm Beach, FL 33402
A magazine dedicated to natural history and nature photography.

Photo District News
49 East 21st Street
New York, NY 10160
This monthly magazine devoted to professional photography contains items of interest for all photographers. A regular column featuring stock agencies and photographers brings up issues of usage fees, negotiation, exclusivity, pricing guidelines, and other newsworthy items. Subscription $30 per year.

Photography Best Sellers: One Hundred Top Moneymaking Stock Photos, by James Ong
New York, NY: Moore & Moore, © 1987
An informative book on best-selling photographs at Ong's agency, Four by Five. The photographs range from shots of clouds to family portraits, and some photos have sold as many as seventy-five times with total sales of over $50,000.

Negotiating Stock Photo Prices, by Jim Pickerell
110 Frederick Ave., Suite E
Rockville, MD 20850
301-251-0720
fax 301-309-0941
This pamphlet is the best guide to pricing today. Pickerell explains how to arrive at the price for an existing photograph through negotiation and includes valuable tables. Buy a copy and keep it near your phone; you can refer to it the next time a buyer wants to know your fee for a photograph. Pickerell also publishes the *Taking Stock* newsletter, about the stock photography industry.